The Photographer's Guide to
LIGHT

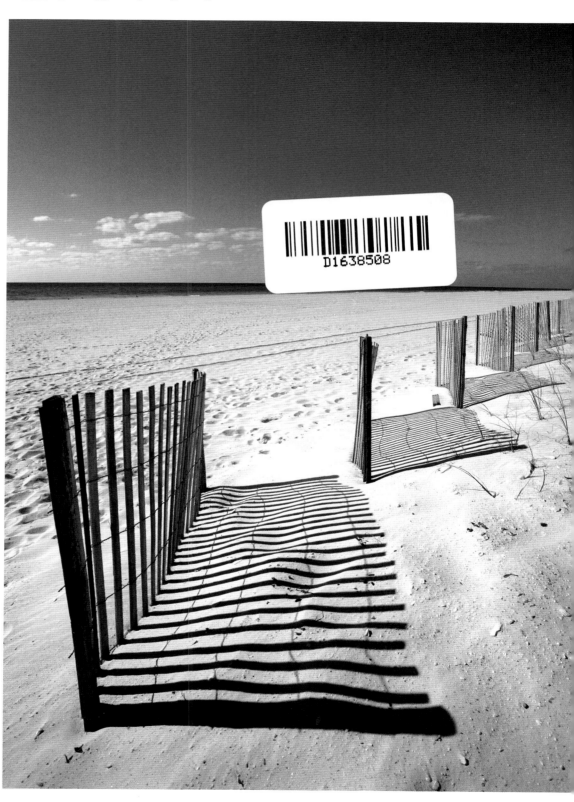

The Photographer's Guide to
LIGHT

John Freeman

COLLINS & BROWN

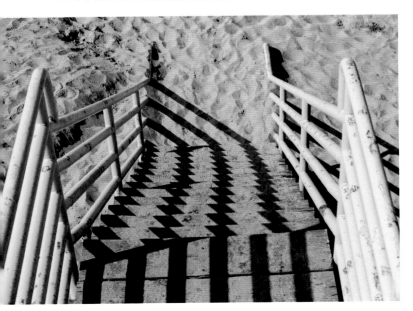

For my sister, Roe

First published in the United Kingdom in 2005 by
Collins & Brown
10 Southcombe Street
London
W14 0RA

An imprint of Anova Books Company Ltd

Photography by John Freeman

Distributed in the United States and Canada by
Sterling Publishing Co, 387 Park Avenue South, New York, NY
10016-8810, USA

ISBN 978-184340-085-1

A CIP catalogue for this book is available from the British Library.

10 9 8 7 6 5 4

Reproduction by Classic Scan Pte Ltd, Singapore
Printed and bound by Craft Print International Ltd, Singapore

This book can be ordered direct from the publisher
at www.anovabooks.com

John Freeman is a highly experienced photographer and the
creator of many books, including the prize-winning *Practical
Photography*, which has sold over half a million copies in more
than twenty counties. In 1989 he published his award-winning
book, *London Revealed* and followed this with the equally
successful *Moscow Revealed*. The photography for these two
books led to him being commissioned to photograph numerous
buildings in the UK for The Royal Collection. Based in London,
he regularly writes for a host of photography magazines,
manages to travel extensively and is currently setting up
photographic workshops throughout the world.

www.johnfreeman-photographer.com
www.jfphotours.com

Contents

Introduction

There are very few of us who don't take light for granted. This is hardly surprising; from the moment we are born we get used to the idea that the sun will rise at the beginning of the day and set at the end of it. Even when it's dark we can produce light at the flick of a switch, so the idea that we will be without it seems outrageous – even outdoors at night streets are lit, signs shine brightly and the light from shops floods on to the pavements.

Light is the essence of our being, and without it life would quite literally be a pretty dull place. Many of our memories are based on what we have seen, and without light these would not exist because no matter how much we might strain, we just

wouldn't be able to see if there wasn't light to illuminate the scene. And so it is with photography, because without light there would be no recorded images for us to look at.

One thing we can be sure of in photography is that light is essential for a good photograph. Without it the chances are that our film, or the sensor in our digital camera, cannot record an adequate image. That said, it is amazing what can be recorded, even in the dullest conditions. As our skill as photographers develops and we become more committed to the image, we start to see the world in a different way. Consider the journey an average commuter makes to work umpteen times a year. Many, when asked in conversation, would probably say

that the journey was boring and that they had seen it all before – it would only be if some sensational phenomenon occurred en route that they might notice anything different. To photographers, however, no journey is boring, no matter how many times we might make it; there is always a new way of seeing the familiar.

When we see something that catches our eye, it is not a cliché to say that we are seeing it in a new light. Because the sun changes its position throughout the year, so too do shadows. It is not just at the beginning and end of the day that these shadows get longer – they alter from summer to winter, and from spring to autumn. Observing these changes is one of the essential steps to getting the photographic vision that is created by light.

Because we take it so much for granted, many of us never really consider the light when we are about to take our photographs. Of course we make the assumption that there is enough of it for the film or the sensor to record an image, or we use flash or some other artificial light source if there appears to be too little. However, it is rare that the light is so low that photography is impossible. When we come to take our shots, what we should consider more than the quantity of light, is the actual quality of light available.

Although we perceive daylight as "white light", it is, in fact, made up of all the different colours of the rainbow or spectrum, ranging from red to violet with five other distinct bands in between – orange, yellow, green, blue and indigo. Naturally

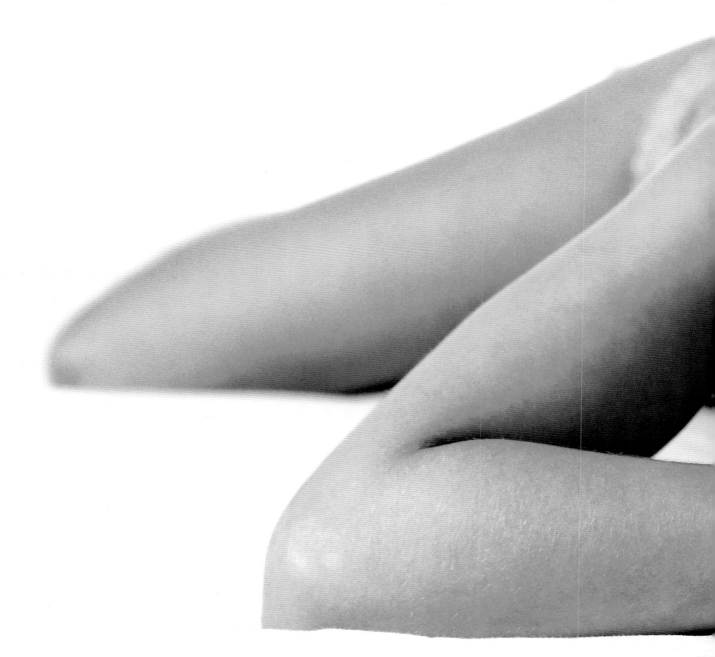

these colours do not stop next to one another, and we usually divide them into three main colour bands – red, green and blue. It is only when we project them in equal intensity that they appear as white light.

However, throughout the day the quality of light changes. On a clear day the rising sun can be quite red or, as we would say in photographic terms, "warm" in colour. The same is true in the evening. But at midday, when the sun is at its highest, the light is bluer, or "cooler".

Because our brains are sophisticated organs that adjust the differently lit scenes that our eyes focus on, we sometimes expect cameras to do the same. However, no camera, no matter how sophisticated it is, can automatically replicate what our brain can do. Admittedly, we can set the white balance on a digital camera to auto, and generally it will make a reasonable job of recording the light correctly. But in certain circumstances, such as mixed lighting or when photographing a sunset, the camera can be misled and results can be less than perfect.

This book is designed to guide you through all the key elements of lighting that you require to improve your photography, by teaching you the difference between how you perceive light and how the camera interprets it.

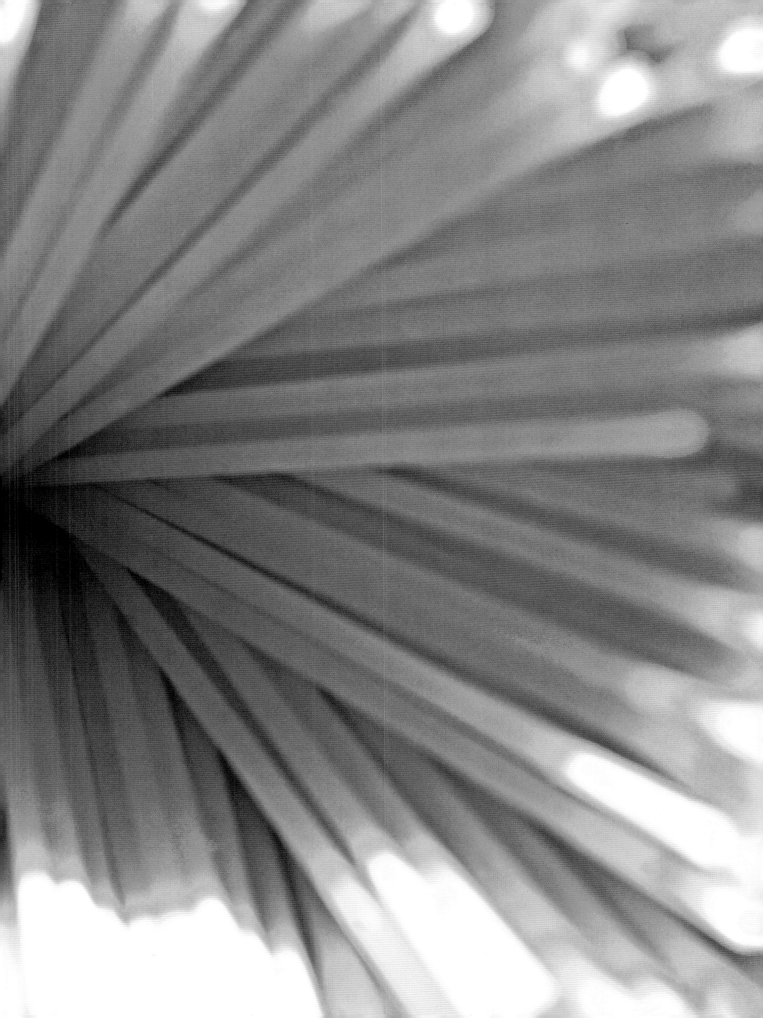

1 The Essentials

Basic Equipment

In addition to your camera, there are many additional items of equipment to help you make the most out of any lighting situation, or to supplement existing light or substitute for it. However, the camera is the place to start, because if this is not up to the job, no amount of accessories, lights, studios or gizmos are going to make any difference.

If you are using a compact camera, either film or digital, you are limited in what you can do with it. Although it may boast a zoom lens, so many millions of pixels, foolproof exposure control and built-in flash, it can never give you the flexibility to take your photography to a higher level. Most of all, you have to ask yourself the question: if all these features are so good, why don't you see any professional photographers using them?

Consider the built-in flash. When was the last time you saw a pro-photographer, be it for press, fashion or paparazzi, using a camera with built-in flash? The answer is never – and that, in terms of supplementary lighting, must tell you its worth. If you are serious about photography, the type of camera that will most improve your results is a single lens reflex (SLR) camera. Both film and, increasingly, digital SLRs are backed up with a range of lenses and accessories that can cover virtually every shooting situation.

When buying an SLR camera, think carefully about the lens. A lens that is set to f1.8 will be faster than a lens that is f3.5 – this means that the faster lens performs better in lower light conditions. The same is true with zoom lenses; many may boast an aperture of f3.5 when set at 70mm, but when the lens is zoomed to 200mm, the maximum aperture is f5.6. If you can afford to, buy a lens that is consistent throughout the zoom range, say f2.8. One absolutely essential purchase when buying your lens is a lens hood (although one should come with the camera). Consider how we put our hands up to our eyes to shield the light; lenses are no different, and you should always have a hood attached to all your lenses – it also helps to protect against damage.

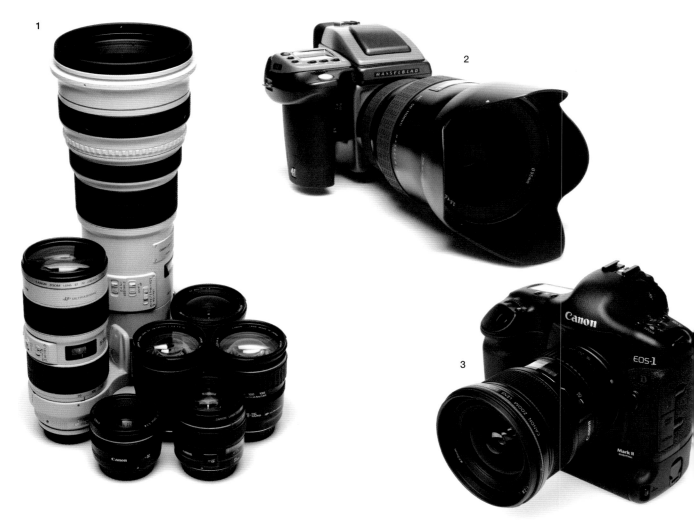

Although many SLRs have sophisticated built-in metering systems, there is no substitute for a hand-held meter. The main advantage of these meters is that you can take incident light readings, which are far more accurate than reflected light readings, the method used with built-in meters. Many hand-held meters can also take flash readings; this is essential if you are considering buying additional lighting.

If you reckon that you are going to be shooting many interior shots, it can be worth buying a colour temperature meter, which tells you precisely what the degrees Kelvin (K) are in any situation (see pages 22–25). This means that you can programme your digital camera to that reading on the white balance setting, or use the correct colour balancing filter when shooting on film.

A dedicated flash gun can be useful in situations such as fill-in flash, slow-sync photography, or where a small amount of additional lighting is required. Although you can sync several of these units together, they can never be as powerful as electronic

1. Interchangeable lenses
2. Medium-format SLR camera
3. Digital SLR camera
4. Polarizing filter
5. 2X lens converter
6. Graduated neutral density filter
7. Screw-on filters
8. Compact flash cards
9. Tripod with pan and tilt head

Basic Equipment Continued

flash, the type used in most professional studios.

Electronic flash is generated from a power pack; these packs come with various outputs, and with some it is possible to plug in as many as four heads. The output is known as joules, and packs are usually 1,600, 3,200 or 6,400 joules. Also available are electronic flash heads with the power built in. These are called mono blocks, and usually have a maximum power output of 1,000 joules. Another type of useful flash is the ring flash, which fits around the lens and gives a virtually shadowless form of light.

All flash is balanced to daylight. Many photographers prefer continuous lighting, or HMI as it is sometimes called, over electronic flash. As its name suggests, continuous lighting gives a permanent light, unlike flash, and is also balanced to daylight so the two types of lighting can be mixed easily. The advantage of this is that you can see precisely the effect the light is having.

Among the accessories that can help.you light your subject are reflectors. These come in various shapes and sizes and with different reflective surfaces, usually white, silver, gold or bronze. Reflectors are great in portrait photography when you need to bounce some light into your subject's face. A tripod and cable release are pretty well essential, especially in low-light conditions where a long exposure is necessary. Graduated neutral density filters help you balance the light between the sky and the foreground in landscape photography, and various light-balancing filters are essential when shooting on film.

1 Flash gun
2 Dedicated flash gun
3 Electronic flash power-pack
4 Exposure meter
5. Ring flash
6. Reflectors
7. Softbox
8. HMI lighting
9. Tungsten light
10. Mono bloc

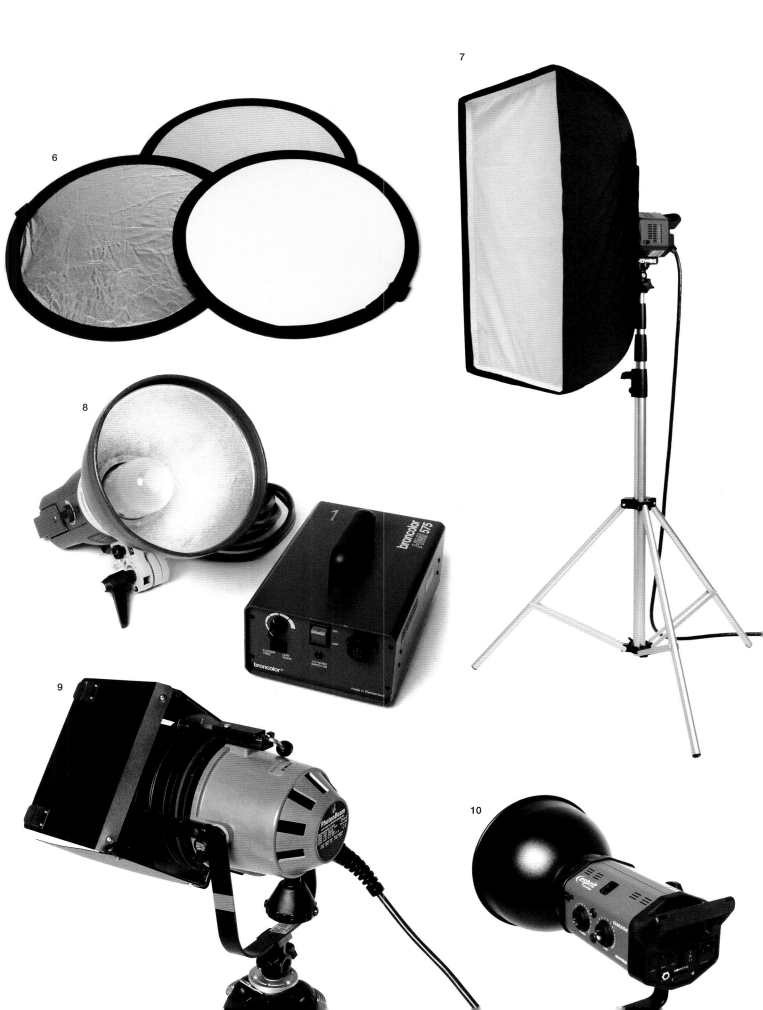

6

7

8

9

10

What is Light?

When we think of light, most of us think of sunlight or of flicking a switch when we arrive home to light up a room so that we can see where we are going. What we see we perceive as "white" light, unless we look through coloured glass or use a coloured light bulb. However, light is constantly changing throughout the day and varies from what in photographic terms we would call "warm", or reddish, at the beginning of the day, to "cool", or blueish, at around midday. What our eyes focus on is analysed by our brain so that the picture we see we think of as "normal", and, generally speaking, we are unaware of the differences in light.

In photography it doesn't quite work out that way, which is why so many people are often disappointed by their photographs when the scene they stopped to take a shot of comes out totally different from how they perceived it. For example, if you are shooting pictures indoors with tungsten light (an average domestic light bulb) but have the camera loaded with daylight-balanced film, all your shots will come out with an orange cast. The same is true if you are shooting digitally and haven't adjusted the white balance to the tungsten setting or used auto white balance. Similarly, if you were to shoot your pictures outdoors with tungsten-balanced film or had the tungsten setting on your camera's white balance, all your shots would come out with a distinctly blue cast (see pages 22–25).

In addition to the difference in colour that is reproduced at different times of day, there is also quite a difference in shadows. At the beginning and end of the day, shadows are long; at midday, when the sun is at its highest and brightest, they are short. If the contrast between light and shadow is too harsh, some areas of the photograph are likely to be very dark, with some detail obscured, and other areas so light that the detail is burnt out. Our eyes can usually accommodate this variation in contrast, but cameras, or more correctly, the film or the sensor, cannot. Understanding how light affects the film or sensor in the way colour is cast and recorded, and seeing how long or short a shadow is, are probably the most important steps in beginning to "see" good photographs.

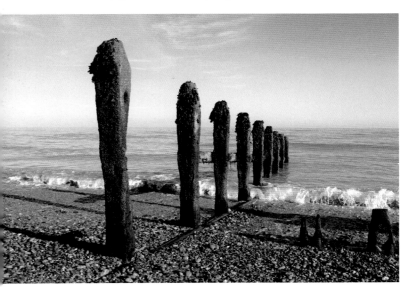

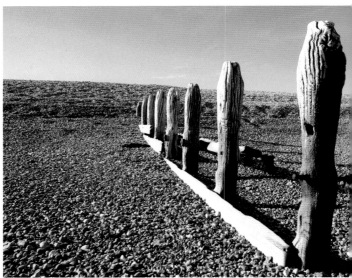

Above: Depending on your viewpoint, photographs can take on a totally different feel in the same light, as these two shots illustrate. In the one on the left, the sun is to the right of the viewpoint and bathes the shingle and the groins in a warm light. However, when I turned through 180°, away from the sea, the light looks totally different, even though this shot on the right was taken within seconds of the first one: it looks much cooler, and the warm light has disappeared. This shows how important it is to look at every angle when composing your shots.

Opposite: The shadows that light makes are the essence of a good photograph. When you are shooting in daylight, the sun is continually on the move so that the shadows change from sunrise to sunset. In this shot the sun is at a low angle to the viewpoint, making the shadows cast by the fence longer.

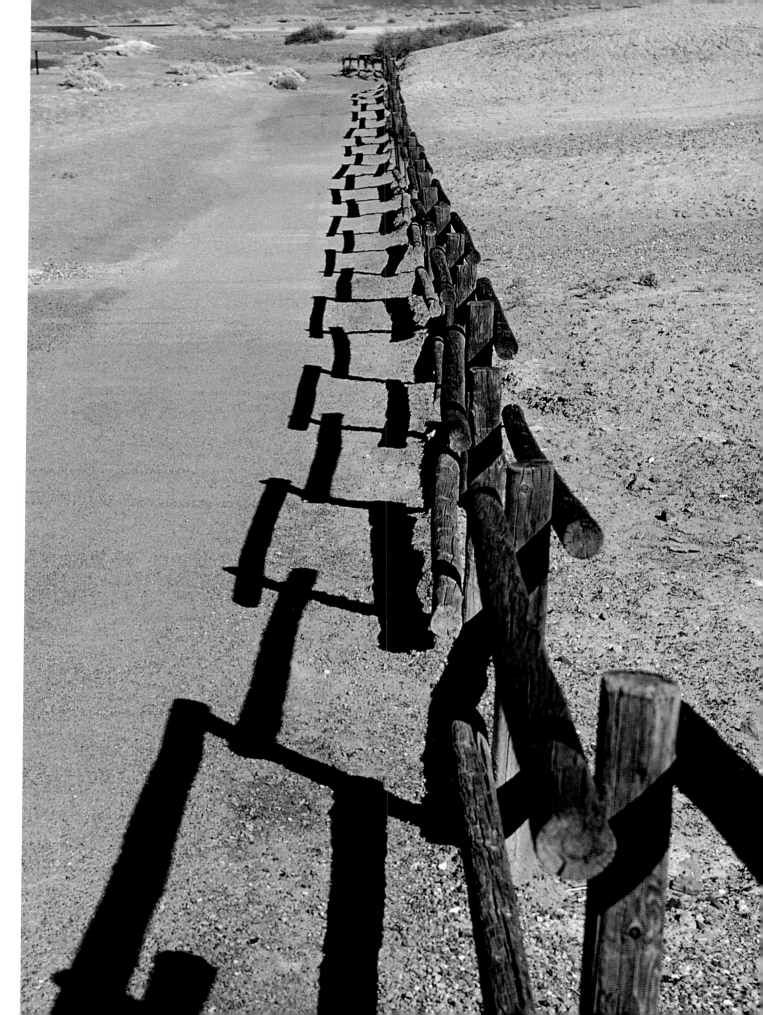

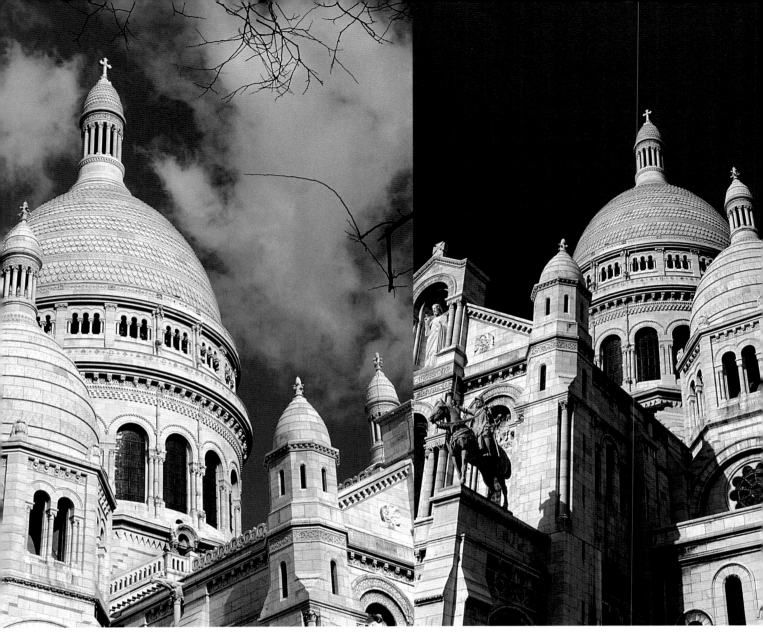

Above: Light is constantly changing, and sometimes you need to be quick to take full advantage of it. I was photographing Sacré-Coeur in Paris and had the camera pointing to the west. However, I looked over my shoulder and noticed black storm clouds encroaching on the building. I walked across the front of the church and took another shot with the camera pointing eastwards. The feel of the two shots are completely different and show that when shooting in daylight the photographic possibilities are endless.

Opposite: These two shots show what happens when you increase the exposure, letting more light reach the film or the sensor. In the shot on the left, the chillies look dull and lifeless. By increasing the exposure, on the right, the chillies now look more vibrant - almost as if they were shot in two different lights.

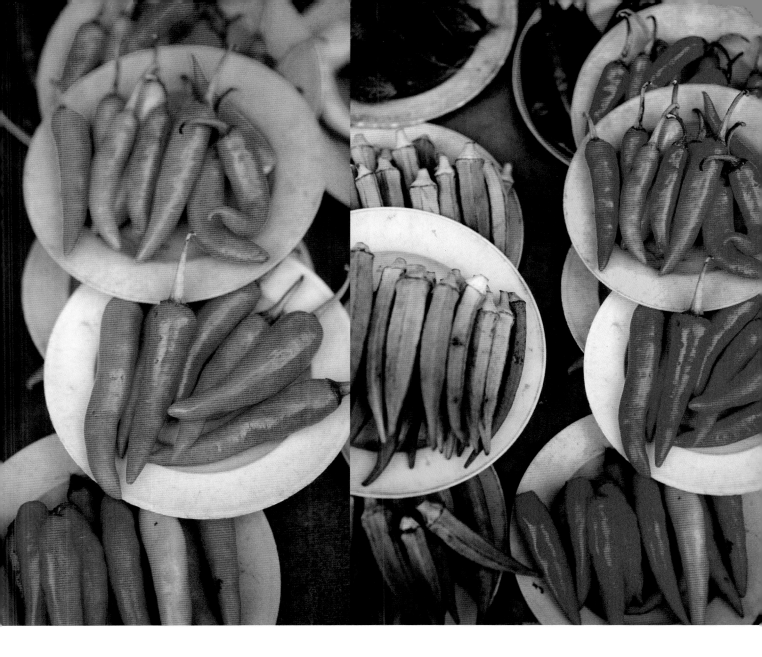

Understanding Colour Temperature

The variation in the appearance of light is measured on a scale known as degrees Kelvin. In photography this is called colour temperature, and the degrees range from approximately 3,200° Kelvin (K), the colour temperature of an average domestic tungsten light bulb, through to about 8,000° K, the colour temperature in the shade under hazy or overcast skies.

When you buy colour film, the packaging usually states that it is for use in daylight or with flash, but in actual fact the daylight that the film is balanced for is around 5,500° K, or the average summer sun at midday; a difference of just a few degrees either side can cause the photographs to be either redder or bluer. When you take pictures at sunset when the light is warmer, this can look very evocative, and the reddish cast helps to make an atmospheric image. However, when taking pictures under hazy or overcast skies, the results can look cold and flat because the film records even the slightest shift in colour temperature, whereas our brain automatically adjusts our eyes to the prevailing light conditions.

If you are going to take many of your pictures in tungsten light with a colour temperature of about 3,200° K, you need to use tungsten-balanced film, otherwise all your pictures will come out with an orange cast. The alternative to this, if your camera is already loaded with daylight-balanced colour film, is to use an 80A filter, which is blueish in colour. The problem here is that because the filter is quite dense, the result is a loss of effective film speed by about two-thirds of a stop. Of course the film can be corrected in the computer once it has been processed, but this can turn out to be a time-consuming exercise if you want every single shot printed on a roll of film!

The same circumstances occur when shooting digitally. Here, you have to adjust the camera's white balance to the different light sources you may find yourself shooting, in the same way you have to use different films or filters.

Depending on how sophisticated your digital camera is, there may be several white balance programs to which you can adjust the camera. For instance, daylight, shade, cloudy, tungsten, flash and fluorescent. In addition, you may be able to set the white balance manually to a range of K settings or use the camera's auto white balance setting. This mode can be useful in mixed lighting conditions, but it can be fooled occasionally.

The principles that apply to film are the same with digital, and unless you change the white balance for different lighting situations, the sensor records the image with a colour cast of varying proportions.

Colour balance
Below: This diagram shows the scale of light as measured in degrees Kelvin. These range from a candle, which has an orange/reddish light of about 2000°K, through to clear blue skies, which measure about 10,000°K.

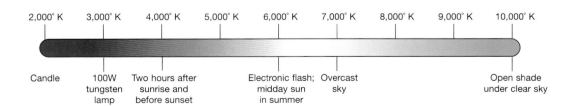

2,000° K	3,000° K	4,000° K	5,000° K	6,000° K	7,000° K	8,000° K	9,000° K	10,000° K

Candle 100W tungsten lamp Two hours after sunrise and before sunset Electronic flash; midday sun in summer Overcast sky Open shade under clear sky

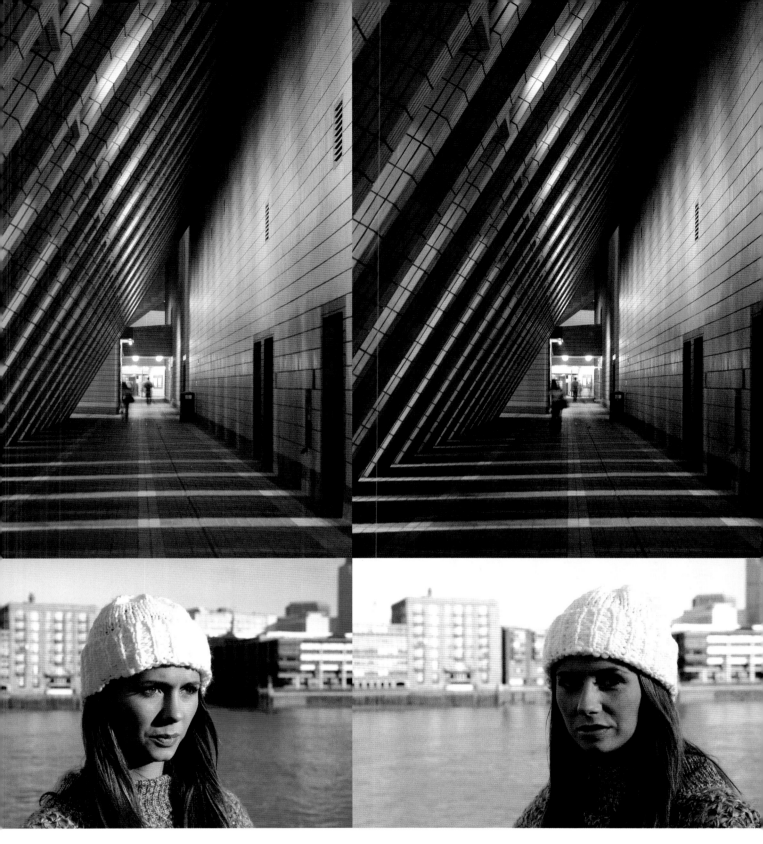

Top: In the shot on the left, daylight-balanced film was used to photograph this building that was lit by tungsten light. This caused the shot to come out with a distinct orange cast. To correct the cast an 80A colour correction filter, which is blueish in colour, was used in the shot on the right. Alternatively, tungsten-balanced film could have been used. The same problem occurs when shooting digitally if you have not set the camera's white balance to the correct setting.

Above: In the picture on the left, tungsten-balanced film used in daylight has caused the shot to come out with a blue cast. To correct this, you can use an 85B colour correction filter, as in the shot on the right, or use daylight-balanced film. When shooting digitally, you need to have the camera's white balance set on the daylight setting, or use the K setting at 5,200° K.

Above: These two shots show how the colour of daylight changes throughout the day. In the shot on the left, which was taken at midday, the shadows are short and the light is quite cool. By late afternoon, in the shot on the right, the sun is much lower and the shadows longer – at this time of day the light's colour temperature has changed and is now much warmer.

Opposite left: In the very late afternoon, the light is even warmer still, and this continues until sunset, when the sky can be bathed in a variety of orange and red light.

Opposite right: By contrast, the light at midday, when the sun is at its highest, is much cooler.

Lenses

In the same way that our eyes focus the light of what we see onto the retina, the lens of a camera focuses the light from the scene being photographed onto film or the camera's sensor. No matter how sophisticated the film or sensor that records the image, if there is not a high-quality lens for the light to pass through, it renders your photograph a poor representation of what you originally saw with your eyes.

Modern sophisticated camera lenses are made up of several pieces of superb-quality convex and concave glass, known as "elements", which are arranged to give the lens its optimum resolution. Some lenses have the letters APO attached to them: this stands for "apochromatic", an arrangement that reduces flare and gives greater accuracy in colour rendition. But such lenses are expensive, as are other pricey lenses equipped with image-stabilization devices, which allow the photographer to shoot in low light conditions at slow speed while minimizing camera shake.

Most cameras come with a variable focal length lens, or "zoom" lens. The focal length of zoom lenses may have a range of 35–105mm, for example; in digital photography, the same range is more likely to be referred to as a 3x optical zoom. The greater the ratio, the greater your scope for framing and cropping your images in camera. Don't be fooled when buying a digital camera by the term "digital zoom" – this means that you are only seeing an enlarged portion of the captured image. Once it is downloaded into a computer, the loss of quality soon becomes apparent.

When light passes through the lens, the greater the distance that it has to travel, the weaker it becomes. Therefore if you are using an ultra-long telephoto lens or you have fitted extension tubes or bellows to your camera, you need to compensate when calculating your exposure. The same is true when certain filters, such as light-balancing or polarizing filters, are placed over the lens. When taking your pictures in bright, sunny conditions, you should have a lens hood fitted at all times.

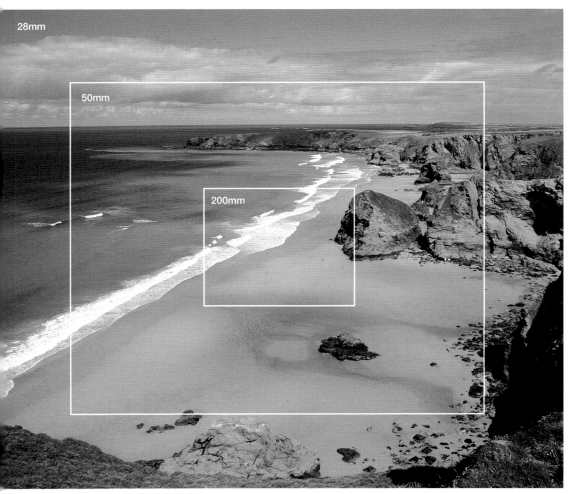

Left: This picture illustrates roughly the angle of view of 28mm, 50mm and 200mm lenses. These three focal lengths are popular choices and are able to cover most situations.

28mm

50mm

200mm

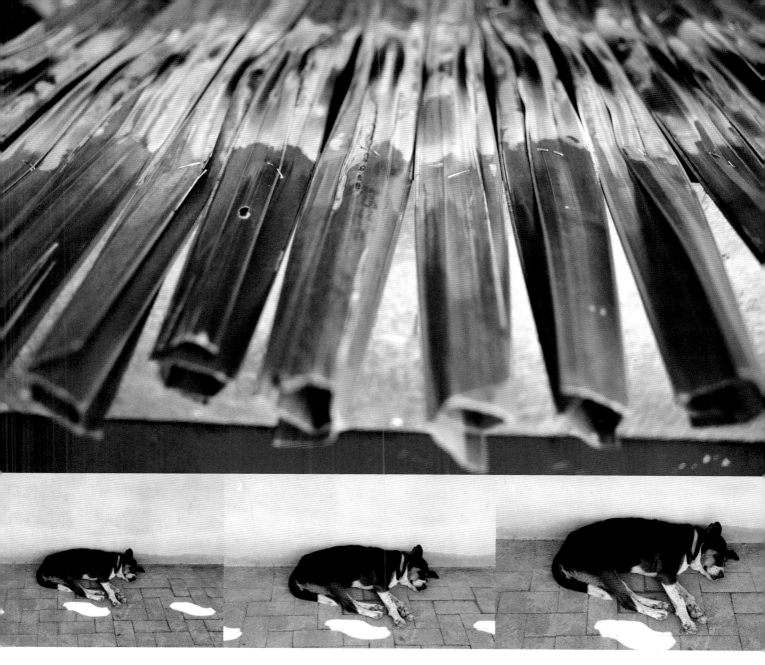

Top: Wide-angle lenses can exaggerate perspective, as can be seen in this shot. They also have greater depth of field than other lenses, which means that more of your shot is sharp without stopping down.

Above: These three shots show how useful a zoom lens can be when it comes to framing your picture. These shots were taken on a 24–70mm zoom lens, which enabled me to fill the frame in the right-hand picture without having to move.

Right: In addition to framing your picture correctly, zoom lenses can be used to create a variety of in-camera effects. In this shot the focal length of the lens was altered (zoomed) while the shot was being taken. This gives the feeling of movement, when in fact everything was static.

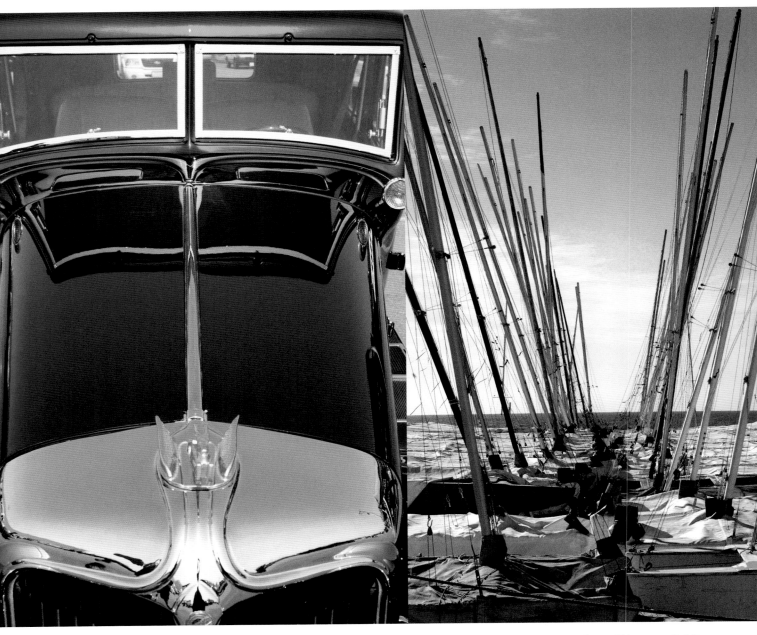

Above left: In this shot an extreme wide-angle lens was used, and the front of the car was only a few centimetres away from the lens. This has exaggerated the length of the car, while at the same time, by using a small aperture, keeping the whole of the vehicle sharp.

Above right: This shot was taken with a medium telephoto lens, which slightly compressed the picture. This means that the space between each boat looks less than it actually is.

Opposite: By contrast, this shot was taken using a 400mm telephoto lens. It makes the London Eye look as though it is just behind the sphinx, which appears in the foreground. The reality is in fact quite different – the River Thames separates the two landmarks.

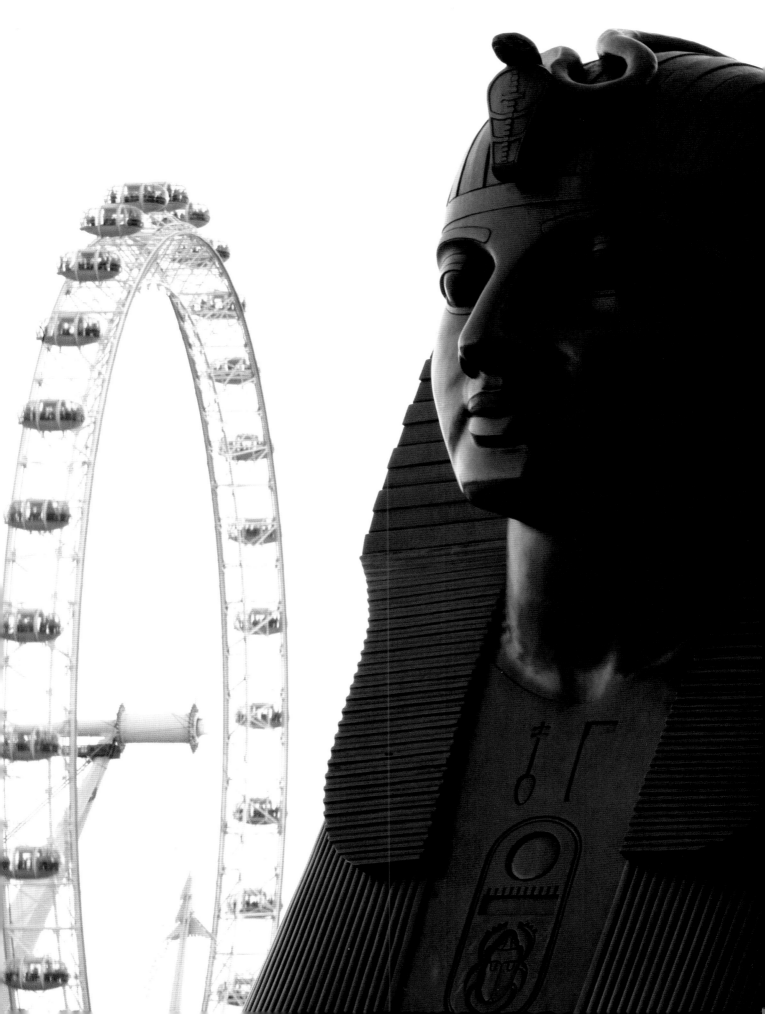

Aperture

The aperture setting determines how much light passes through the lens onto the film or the sensor, and also determines the plane of sharp focus or the depth of field.

Behind the lens is a diaphragm made up of ultra-thin blades, which fan in or out to make the aperture. When the aperture is set at f2.8, for example, the amount of light that passes through the lens is greater than when it is set to f16 or f22; these settings are sometimes called wide-open or stopped-down settings. On some lenses the widest aperture can be as much as f1.2 and the smallest f64, and in between are a series of other aperture settings: f5.6, f8, f11 and so on. The difference between one number and another is known as a stop. Setting the aperture to one stop difference in either direction increases or decreases the exposure by half – in other words, one stop increases or reduces the amount of light reaching the film or sensor by half. On more expensive cameras it is possible to set the aperture at one-third increments for the most accurate control of exposure.

The wider the maximum aperture to which you can set your lens, the "faster" it is. For instance, a lens with a maximum wide aperture of f1.4 is faster than a lens with a similar aperture of f2.8. Faster lenses are useful in low light conditions, as they have a greater ability to record an image without having to use additional light sources such as flash.

On some cameras the built-in metering system is called aperture priority (AP): you set the aperture and the camera chooses the shutter speed. This is useful to control depth of field: when you focus the camera's lens on a subject that is, say, 6ft (2m) away and use a wide aperture such as f2.8, very little that is behind the subject and even less in front is in sharp focus. The distance on either side of the focus point is known as depth of field. When you stop down, use a smaller aperture setting so that depth of field increases, a greater area in front and behind the point of focus is sharp. When using an SLR camera, you can preview the depth of field before you take your shot, thus having greater control over the final composition.

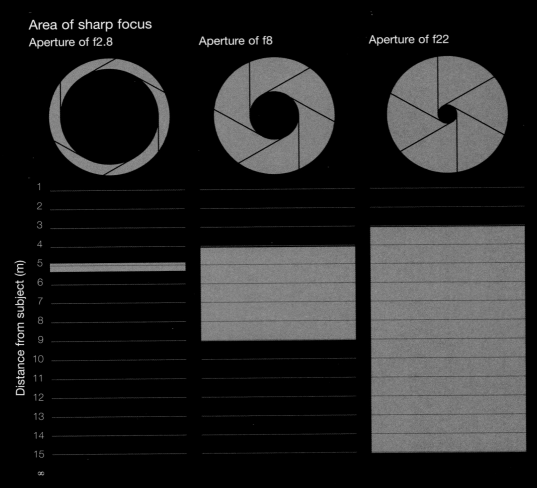

Area of sharp focus

Aperture of f2.8 Aperture of f8 Aperture of f22

Distance from subject (m)
1
2
3
4
5
6
7
8
9
10
11
12
13
14
15
∞

Left: When the aperture is at its widest very little of the picture is sharp, while the smaller the aperture, the greater the area of sharp focus.

Opposite: (1) A 28mm wide angle lens was used with an aperture of f2.8. Much of the picture is in focus with only a slight fall-off in the very front and in the far distance. (2) With the lens stopped down to f8, more of the picture is in focus, or sharper. (3) With the lens stopped down to f22, all the background and the foreground are in focus. (4) Using a 50mm standard lens and an aperture of f2.8, far less of the picture is sharp than with the aperture used in picture 1. With the lens stopped down, first to f8 (5) and then to f22 (6), more of the picture is sharp, but it still does not compare to the sharpness of the wide angle lens. With the lens changed to a telephoto lens such as 200mm, very little is sharp when using an aperture of f2.8 either side of the focus point (7). With the lens stopped down to f8 (8), not much more is in focus, and when the aperture is adjusted to f22 (9), only slightly more in front and behind the point of focus is sharp.

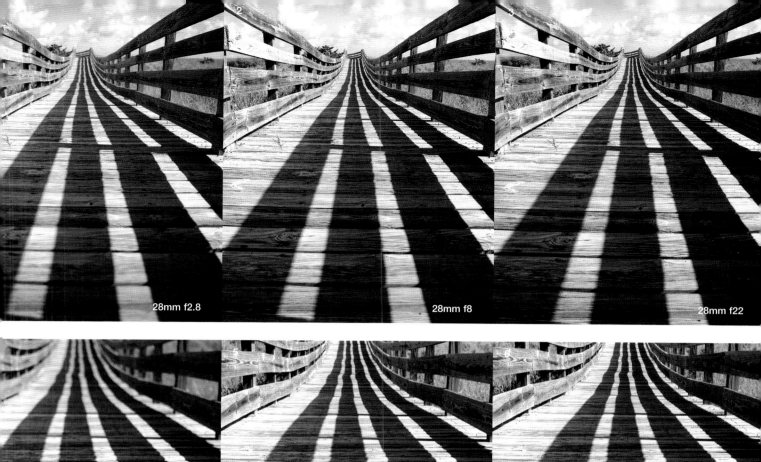

28mm f2.8

28mm f8

28mm f22

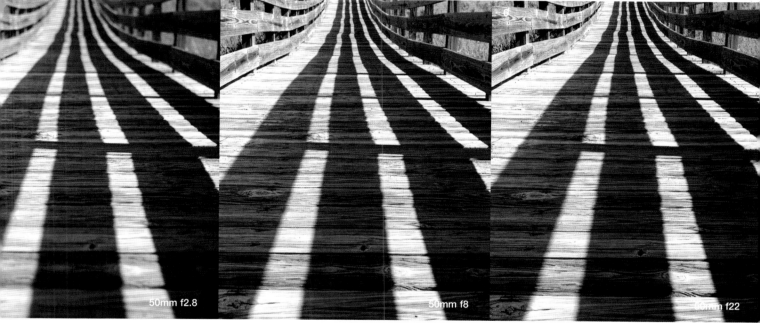

50mm f2.8

50mm f8

50mm f22

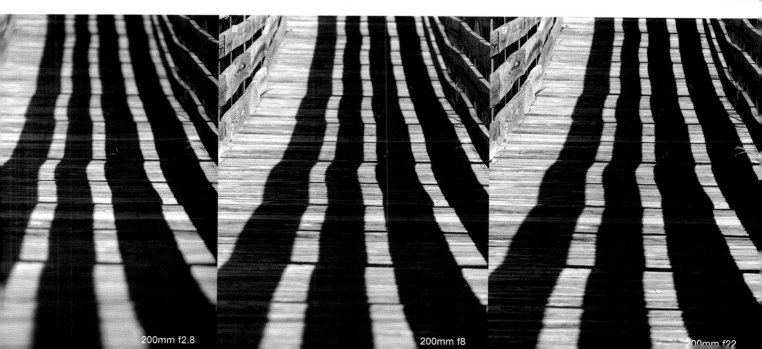

200mm f2.8

200mm f8

200mm f22

THE PHOTOGRAPHER'S GUIDE TO LIGHT

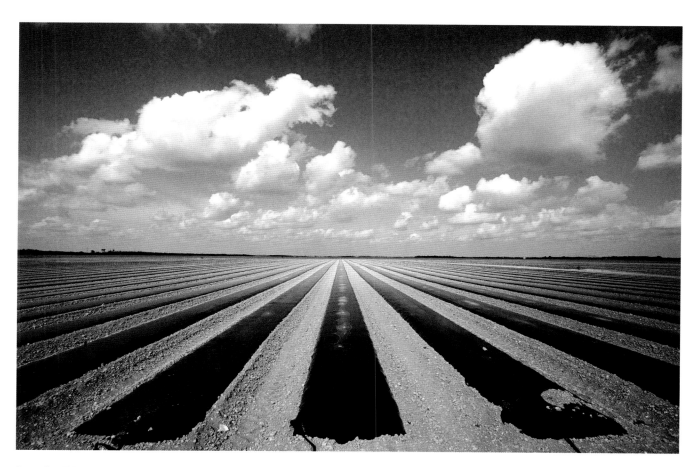

Opposite: This shot was taken on a 100mm telephoto lens. When working this close, the depth of field is minimal, especially in the foreground.

This can be put to good use if you want to highlight one area of your shot.

Above: With a wide-angle lens, in this case a 16mm, the depth of field is far greater, even when the lens is not stopped down. This is useful if you want as much of the shot to be as sharp as possible, especially if the light is low.

Right: In the upper shot I set the lens at an aperture of f16. This resulted in the background being quite sharp, which is distracting. By opening up the lens and selecting an aperture of f2.8, the depth of field in the lower shot is far less and the background is now less defined. This puts the emphasis on the portrait, which is no longer competing with the background.

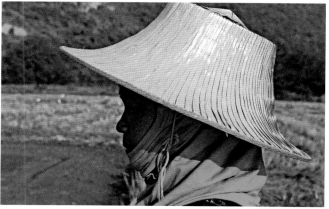

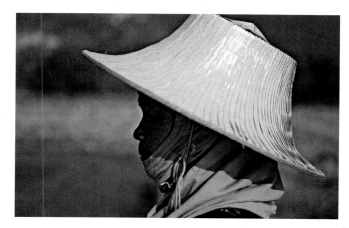

Shutter

Where the aperture determines how much light passes through the lens, the shutter determines for how long the light is allowed to reach the film or the sensor. The shutter also determines whether a moving subject is sharp or blurred. A facility to change the shutter speed is only available on more expensive camera models.

The first main type of shutter is the focal plane type, which works by moving a curtain across the film or sensor to expose it to light; the second is the leaf type, which opens and closes in much the same way as the aperture diaphragm. The main difference is that the leaf shutter synchronizes with flash at all speeds, while the focal plane shutter only synchronizes at shutter speeds up to a maximum of 1/250th second, depending on the model.

An adjustable shutter is likely to have a range between 1 second and 1/1000th second; on very sophisticated SLRs, the shutter can range from 30 seconds at one end of the scale to 1/8000 second at the other. A setting marked with the letter B is for time exposures and keeps the shutter open for as long as the shutter release button is depressed.

Imagine you are standing at a fixed point and your subject is moving rapidly from left to right. If you have set the shutter speed to 1/60th second or slower and take your shot with the subject directly in front of you, it can come out blurred with no detail. However, if you adjust the camera's shutter to 1/1000th second or faster, your subject comes out 'frozen' or sharp and all the detail is visible.

You can use an adjustable shutter speed in combination with the aperture. When shooting a portrait on a bright day, your exposure meter might indicate that you need to set the camera at 1/125th second @ f16. However, this increases the depth of field and makes the background sharp. If the background is uninteresting or is an intrusion into the overall composition, the finished shot can lack quality. By adjusting the shutter to 1/1000th second and opening the lens to f5.6, you put the background out of focus and isolate your subject against it.

Moving subjects

These shots show the different effect the shutter has on a moving subject. With a slow shutter speed (1), the water is quite blurred. As you move through the shutter speed range, the water looks sharper, and when you use a fast shutter speed (6), it looks "frozen".

Knowing how to use the shutter in this way means that you can use it to create effects such as the shots opposite below. The first picture was taken with the shutter set on 1/4 second, creating movement in the water and giving life to the shot; in the second shot a shutter speed of 1/500th second was used and the water has no movement in it.

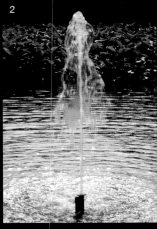
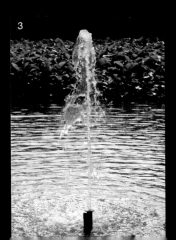
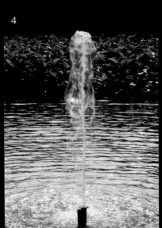
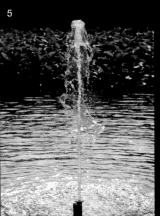

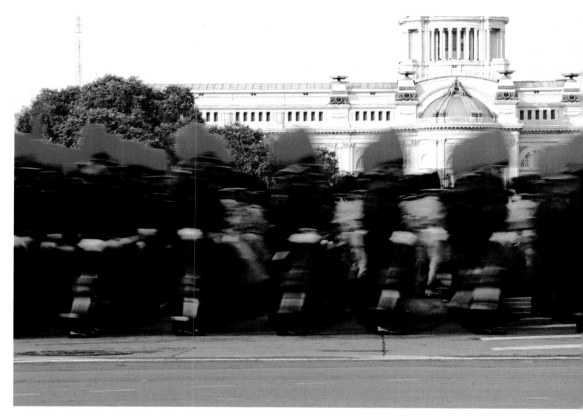

Right: In this shot I used a shutter speed of 1/15th second and had the camera mounted on a tripod. This meant that the building in the background remained sharp while giving the appearance that the soldiers were really on the march.

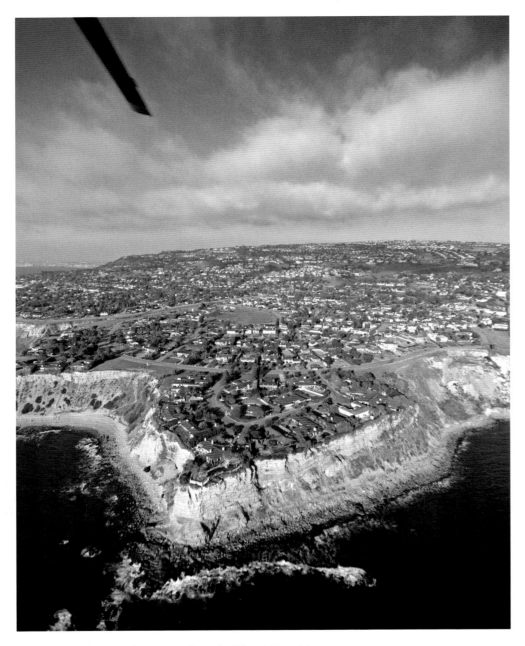

Above: When using ultra-fast shutter speeds, it is possible to include unwanted detail in your shots. I took this picture from a helicopter over the west woast of California using a shutter speed of 1/8000th second. At this speed the helicopter's rotor became "frozen" in the frame and had to be retouched out.

Opposite: When taking pictures at night there might not be enough light, even when you are using a wide aperture, to record an image on the film or sensor. In this case you need to mount the camera on a tripod and use a slow shutter speed to compensate for the lack of light.

Exposure

Using a camera with an adjustable aperture and shutter gives you far greater control over exposure than a camera where the exposure is fixed or is determined with a built-in meter that does not allow you to override it. Unless you have purchased a medium- or large-format professional camera, the chances are that your camera has a built-in metering system; such systems operate in a variety of ways and give you the choice of adjusting the exposure settings manually or letting the camera do this for you.

Most cameras have centre-weighted metering systems, where the meter reads all the light being reflected from the total scene that you see in your viewfinder. However, this is biased towards the central part of the scene, so if your subject is in the centre of your frame, the meter reads more accurately for that, not the area behind it.

For really accurate readings, it is an advantage to have a camera that has a spot reading method, where the camera's meter reads only 2–3 per cent of the centre of the frame –

particularly useful when taking backlit portraits. Another exposure mode is where the camera uses the partial metering method; like the spot metering method, this records a central area of the frame, but in the region of 8–10 per cent.

The one thing that all these metering methods have in common is that they read the light being reflected off your subject. While this is acceptable in most shooting situations, a far more accurate method is incident light reading, where the meter reads the light falling on the subject, not the light reflected from it. To use this method you need to have a separate hand-held meter. Using the incident light method means that you point the meter at the light source – unlike the reflected light method, where you point the meter at the subject. Most hand-held meters are quite compact and can read using the incident light method and can also read reflected light in a variety of different modes, such as spot metering. Some hand-held meters also double up as a flash meter, so they are definitely worth considering if you are serious about your photography.

Varying exposure

Right: The levels in (1) are bunched towards the upper end of the histogram, to the right of the camera's LCD. This indicates that the brighter parts of the image are burnt out and overexposed. In (2) the levels are spread through the histogram evenly, showing an even spread of tones. The levels bunched in the middle show a good exposure for an average subject. The exposure data of a digital image is displayed as a histogram on the camera's LCD. In (3) the levels are bunched to the left and blocked in, showing underexposure.

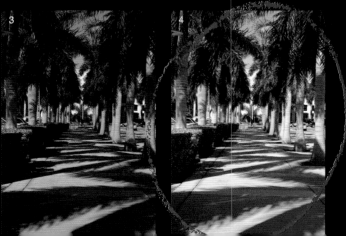

Right: In late afternoon or early evening light it is essential to keep the ambience of the lighting. This can mean using a slow shutter speed, which may result in areas of the picture being blurred, such as the seagulls. By opening up the aperture, a compromise can be reached so that all the elements of the shot are recorded as required.

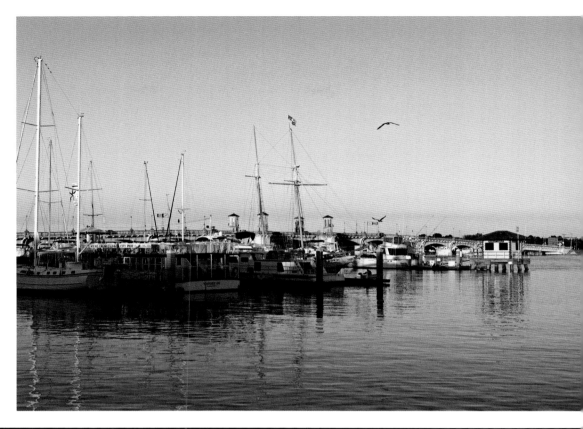

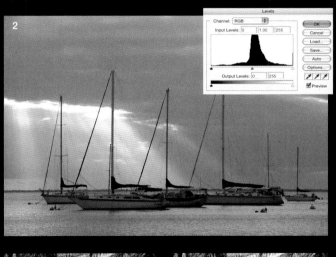

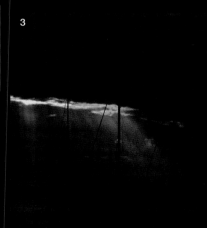

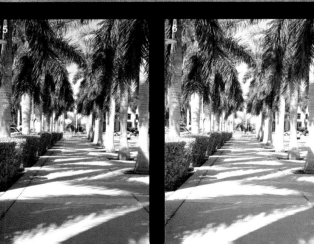

Left: In this series of pictures you can see the effect of bracketing the exposures. In (1) the shot is too dark and underexposed. By gradually increasing the exposure, the shot becomes lighter. (4) has the correct exposure, while increasing the exposure (7) results in overexposure. Although an acceptable print might be possible with images 3 and 5 the others will result in a loss of detail.

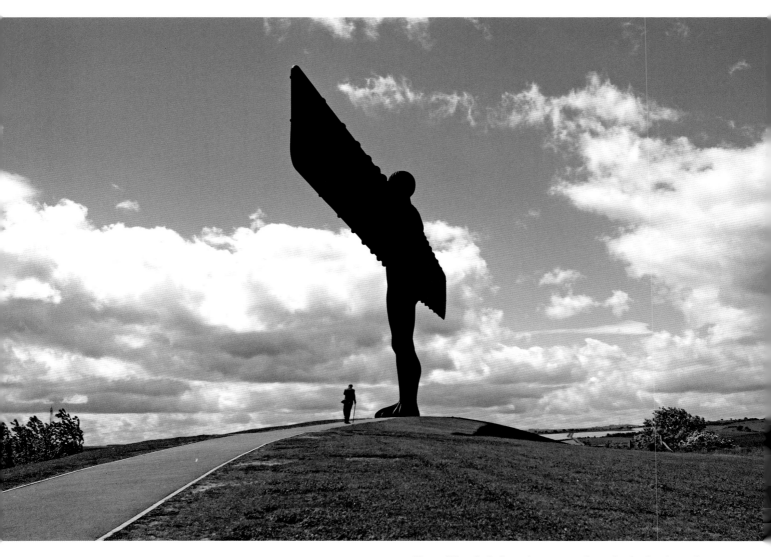

Above: When including a large amount of sky in your shots, there is always the danger that other detail may be underexposed. Check the histogram carefully on your camera's LCD to ascertain a good distribution of tones to achieve the optimum exposure.

Opposite: In situations where there is a good deal of contrast, such as this shot of a floating market in Thailand, care needs to be taken so that all the elements of the shot are reasonably exposed. Here, there is just the right balance between the bright water on the right and the boats in the shade on the left.

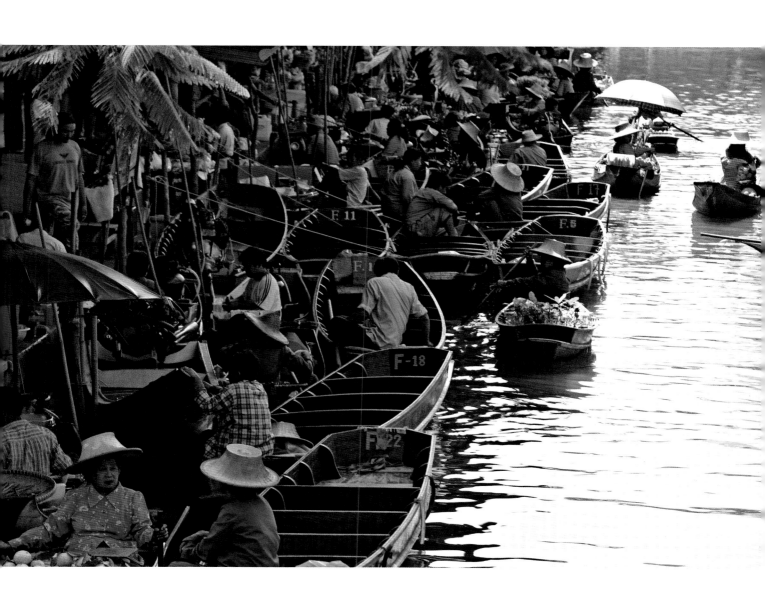

Understanding ISO

All film comes with an ISO rating, which stands for International Standards Organization rating. ISO superseded the older ratings, ASA (American Standards Association) and DIN (Deutsche Industrie Norm). At the same time, ISO is also applicable to digital photography, and many cameras at the higher end of the range have a facility that enables you to adjust the ISO setting.

The different ISO numbers allotted to film indicate the sensitivity to light of that particular film. The lower the ISO number, the less sensitive to light it is; the higher the ISO number, the more sensitive it is. The range of film speed varies from 12 through to 3200 ISO. If you are shooting in low-light conditions, it may not be possible for a slow film – 50 ISO, say - to record an acceptable image. For example, if the exposure required in this type of light is 1 second @ f5.6 and it is not possible to supplement the light with flash or use a tripod to keep the camera steady, the outcome is very likely to be a wasted shot. However, using a faster film, such as 1600 ISO,

the exposure required is 1/30th second @ f5.6. This is an extreme example, but it does show the correlation between ISO and exposure, and the same is true if you shoot digitally and adjust the camera's ISO dial correspondingly.

Another way to increase the speed of a film is to have it push-processed. This means that if your camera is loaded with 400 ISO film, you can rate it at 800 ISO, thus doubling the film speed; when you come to have your film processed, you tell the lab that you want it pushed one stop. The drawback with this is that you have to shoot the entire film at the increased ISO rating, as any frames shot at 400 ISO come out overexposed if the film is push-processed in development.

Using fast film, the size of the grain (known in digital photography as "noise") increases the higher the ISO, and this can become unacceptable in shadow areas, as it causes a loss of image sharpness. However, using a computer and a program such as Photoshop you can add noise to creative effect, either to an image shot digitally or shot on film and then scanned.

Fine grain

When the chosen ISO is 100, photographs have a fine grain or noise – and even when the shot is enlarged (right) and the grain or noise increases and the sharpness begins to suffer, the result is still acceptable.

Coarse grain

With the ISO at 1250, the grain or noise increase dramatically and the overall sharpness of the shot begins to diminish (right). When the shot is enlarged this becomes even more apparent; in certain situations this is unacceptable, but, as in the shot on the opposite page, grain can add a dimension to the image that makes it more attractive.

Daylight

It is surprising how many people who take a lot of photographs seriously believe that daylight, especially on a bright and sunny day, is the optimum light for getting a good photograph.

However, to the experienced photographer this type of light can be full of hazards. Bright daylight tends to create a great deal of contrast, so the difference between the shadow and the highlight areas is greater than most films or sensors can accommodate. If taken in these conditions, the finished image may have burnt-out highlights or shadows that are so black there is little or no detail recorded at all.

When shooting portraits (see pages 63–73), bright and sunny daylight can be uncomfortable for your subjects, making them screw up their eyes or forming heavy shadows under the chin, nose and eyes. A good test for judging how strong the contrast may be in a photograph is to look at the scene with your eyes partially closed. You can do this right now: if the scene is evenly lit, nearly all the detail will be visible, even with your eyes half shut; however, if there is something that is very bright in the scene, items or areas in shadow become quite dark and any detail is hard to discern.

Another problem with strong daylight is colour casts. These can occur when your subject is positioned close to a brightly coloured surface that reflects back onto them, causing their skin to absorb an unnatural glow; this can also be the case with brightly coloured clothing. Remember the childhood game of holding a buttercup under a friend's chin to see whether they like butter? The buttercup reflects its colour onto the skin and makes it appear yellow; and so it is with anything else off which the sun can reflect.

Daylight is subject to huge variations, due to the time of day or year, the weather or the geographical location. Its colour temperature (see pages 22–25) varies enormously: morning and evening light tends to be red or warm, while daylight on overcast and cloudy days can appear to be quite blue or cold. It is exactly these variations that can add atmosphere to shots, so think carefully before using colour correction filters or adjusting the white balance on your digital camera.

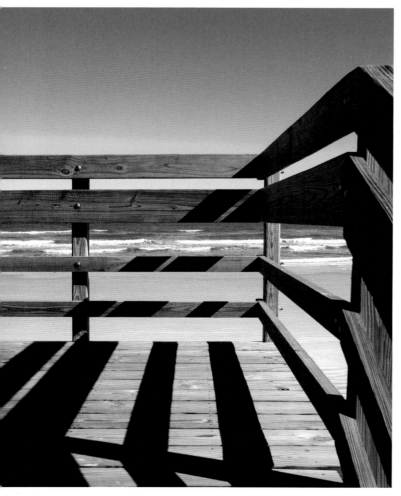

Left: If the conditions are right, daylight has the ability to create strong graphic images. Here, the shadows cast by the bright sunlight create strong geometrical patterns on the wooden boardwalk.

Opposite top: In contrast, the shadows falling on the building are softer but still make an interesting pattern on the wall. If I had waited another hour or so, both these shadows would have disappeared and the shots would have looked quite different.

Opposite bottom left: In this case, the sun has created a dappled effect by filtering through the leaves of the grapevine to give the impression of summer and the feeling of warmth. Using patterns like this can dramatically alter your photographs.

Opposite bottom right: When taking portraits in daylight, take care that the sun is not too bright, making your subject squint. I turned my model round so that her back was to the sun. This created a nice highlight on her hair and made it far more comfortable for her.

Overleaf: Even the mundane can make good pictures if the light is right. I came across this dead palm leaf in a tropical forest, highlighted by a shaft of sunlight that made it stand out from the rest of the foreground. I took a low viewpoint with a wide angle lens to create a strong perspective and make a dull area of ground interesting.

Tungsten Light

After daylight, probably the most common form of artificial lighting that we perceive as natural is tungsten light, the light emitted from the average domestic light bulb. To the naked eye, this type of lighting looks completely natural, and a white object viewed in this light still appears to us as 'white'. However, tungsten light comes from a far lower temperature on the Kelvin scale – about 3,200° K – than daylight.

When shooting in tungsten light with daylight-balanced colour film, shots come out with a distinctly orange cast. To correct this, you need to place an 80A colour correction (CC) filter over the lens (see pages 150–153): this is blueish and corrects the orange cast, making the captured image look more natural when viewed. The drawback is that such a filter cuts down the amount of light passing through the lens onto the film, requiring an increase in exposure. To do this you can either adjust the speed or the aperture or, if all your shots are being taken on the same roll of film, you can adjust the ISO: for example, if you are using 100 ISO film, you can adjust the meter to 200 ISO.

The alternative is to buy tungsten-balanced film, available as both colour reversal – which produces colour slides or transparencies – and colour negative film. The advantage is that this film doesn't suffer from reciprocity failure, where a film becomes unstable. When making exposures with daylight-balanced film of 1 second or longer, the speed of the film, or its sensitivity, starts to decrease: if your exposure meter indicates 2 seconds @ f8, the true exposure required may in fact be 3 seconds @ f8; if it says the exposure should be 4 seconds @ f8, it might in fact require 8 seconds, and so on.

When shooting digitally, the choice is more simple, as all you need to adjust is the camera's white balance to the tungsten setting or the K (Kelvin) setting to 3,200° K. You can also set the camera to auto white balance. If you forget to set the white balance correctly, you can always correct your shots on the computer once they have been downloaded.

Left: This shot was taken on daylight film in an interior lit by tungsten light. The balance is just about acceptable and can be corrected later after the transparency has been scanned and downloaded into the computer. However, there is no substitute for getting the balance right in the first place, whether shooting on film or digitally.

Opposite top: These two shots illustrate what happens if you do not have the camera's white balance set correctly. In the shot on the right the white balance was set to the daylight setting, causing it to come out with an orange cast. Although this could be corrected at a later date, it is far better to get the shot right first time by setting the white balance to the tungsten setting (left).

Opposite bottom: In the shot on the right the camera's white balance was set to the daylight setting, which would seem sensible as the picture was taken outdoors. However, the sky looks dull and the building, lit by tungsten light, looks unnaturally orange. With the white balance setting changed to the tungsten setting, the sky becomes far brighter and the lights shining on the building look more realistic.

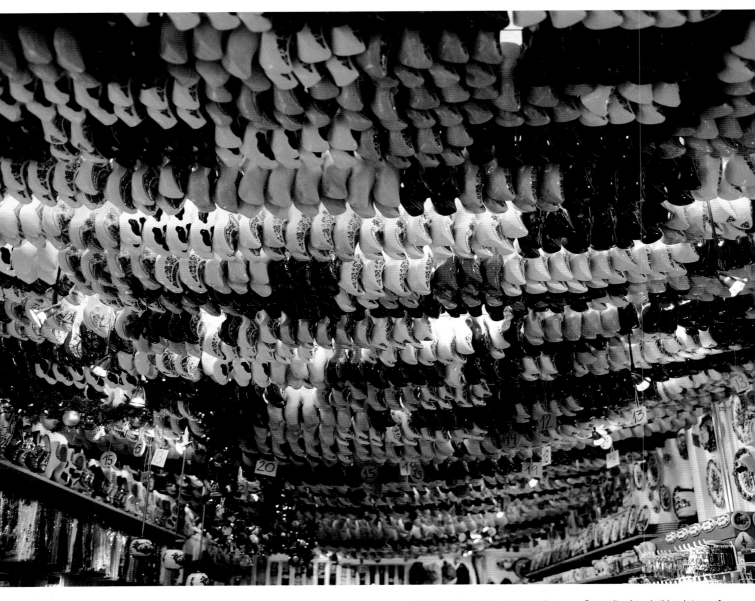

Above: When taking this interior shot of a Dutch clog shop I set the camera's white balance to tungsten, which gave a correct colour rendition to the shot.

Opposite: I took this picture of London's Royal Opera House using the theatre's own house lights, which were all tungsten-balanced. I set the camera's white balance to the tungsten setting, and the result is a perfectly colour balanced shot.

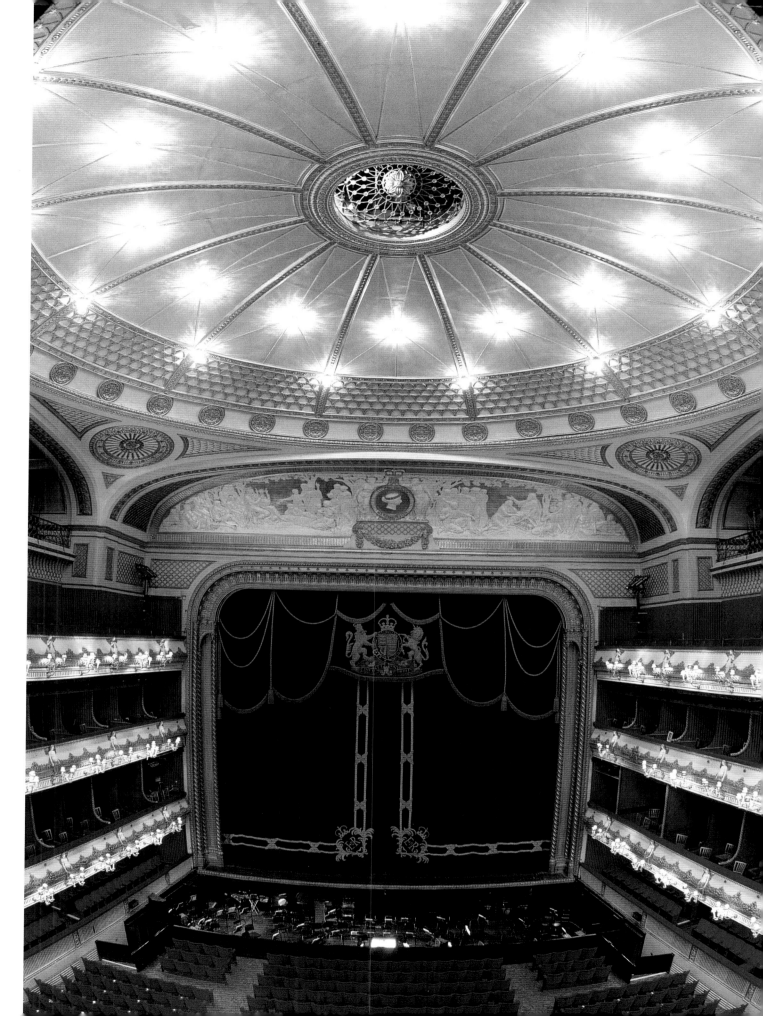

Fluorescent Light

Of all the artificial light sources, fluorescent lighting is probably the most difficult to work with. There are so many different types of tubes – daylight, warm light, cool light and so on – that it can be problematic when it comes to choosing the correct colour correction (CC) filter to balance the film. Not only that, but in any one room or lighting situation there could be a mixture of all these different types. To the naked eye, all these tubes appear to give the appearance of white light; however, if you shoot on film in this type of light, the results have a distinctly green cast – the same is true when shooting digitally if you do not adjust the camera's white balance.

To get the most accurate reading when shooting in fluorescent light, use a colour temperature meter. This looks very similar to a conventional exposure meter, except that it reads the colour temperature of the prevailing light and indicates the CC filters required for either daylight- or tungsten-balanced film.

Several different types of CC filters available are supposedly suited to different fluorescent tubes. However, it is not always possible to ascertain exactly what tubes are being used, as they may be fitted high in the ceiling.

Getting good results is often a matter of trial and error, together with experience: a good combination is a 40 magenta filter with a 10 blue colour correction filter. This combination absorbs most of the green cast caused by fluorescent tubes and gives adequate results under most conditions. Because magenta and blue absorb so much light, you may have to make an adjustment in your exposure by as much as one stop. Low light in turn necessitates a lengthy exposure time, so using a tripod is essential. If your processed film still has a green cast, you can scan this and adjust the colour on your computer, but this can be a time-consuming operation.

When shooting digitally, you need to set the white balance to the K mode. However, because of the uncertainty over exactly what fluorescent tubes you are having to shoot under, it can be better to set the white balance to the auto mode. In either case, you can make fine adjustments once you have downloaded your pictures into your computer.

Above: Fluorescent light can give a strong green cast if not filtered properly or if the white balance is not set to the appropriate setting. The trouble is that there are so many different varieties of fluorescent tubes that choosing the correct filter can be a problem, as seen here.

Left: In this shot of an American diner the balance is just right; I used a combination of a 40 magenta and a 10 blue colour correction filter. For really accurate results you can use a colour temperature meter to work out the precise filter combination; these meters are expensive, however.

Opposite: This shot was taken inside the space shuttle module, where I set the white balance on my Canon 1DS to the fluorescent setting. This has given a perfect rendition of colours without the need for filters.

Continuous Light

Continuous light, or HMI, was developed primarily for the television industry as an alternative to tungsten lighting, which is bulky to move around, uses a lot of power, and is therefore expensive to run, is not particularly powerful, and needs to be balanced to daylight.

Although electronic flash is the most popular form of artificial lighting for still photography, as it has none of the problems or drawbacks of tungsten light, HMI does have its uses and many photographers use it frequently, if only for one, very important, reason: you can see exactly where the light is going and the effect it is having on the scene that you are photographing. Although electronic flash units have modelling lights to help you with the power and direction of the flash, these are intended only as a guide, and they cannot be compared to the quality of the light that is delivered when the flash is fired.

HMI is an acronym of the three constituent parts: Hg, the symbol for the chemical element mercury, M, for medium arc, and I for iodides. Because these lamps are daylight-balanced they can be combined with electronic flash and of course daylight; and unlike tungsten lamps, which have a colour temperature value of 3,400° K, HMI lights are balanced to 5,500° K. They are also suitable for long exposures, where (again unlike tungsten lamps) they run cool, which makes for a more comfortable working environment. HMI can be fitted with numerous types of reflectors and softboxes, in addition to a variety of light-shaping devices.

However, similarly to tungsten, HMI lamps cannot possibly match the power or spread of electronic flash. Additionally, they require what is called a "ballast" unit, a pack that takes the power from mains electricity and delivers it to the HMI lamp, making it flicker-free.

HMI are also slow to use, as the lamps need a certain amount of time to reach the correct operating temperature. On top of this, the ballast is not a lightweight unit – and the more powerful the lamp, the heavier the ballast. Finally, HMI lamps are not cheap and are as vulnerable to breaking as any other unit made of glass, so they need to be handled with as much care as an electronic flash tube.

Left: The great thing about HMI lighting is that it is balanced to daylight. In this shot I used one HMI head fitted with a soft box to fill in the shadow areas of the bed on the right-hand side. With this type of lighting you can see the effect as you position it.

Opposite: In this shot the bright orange wall would have come out as totally the wrong colour if I had used tungsten light to fill in the shadow area on the stairs. If I had used the tungsten setting on the camera's white balance, the daylight on the lower part of the stairs would have come out blue.

Flash

Flash is probably the most common form of photographic lighting after daylight. Many cameras come with built-in flash, the exceptions being the professional models at the top end of the market – it is the absence of a built-in unit in these cameras that tells us how useful they really are.

Most people have watched a football match or a concert and witnessed the sporadic flash of cameras being fired from the audience. These shots are bound to fail because built-in flash units are only capable of illuminating a subject that is probably no more than 9ft (3m) away from the camera. Even if the units were capable of illuminating the stage or pitch, the quality of light would be bland and cold. The ambience of the stage lighting would be lost, and the atmosphere of the event, which was the purpose of taking the shot in the first place, would be reduced to a mere record of the space.

A perennial problem with built-in flash units is red eye: in low-light conditions the eye's pupils dilate or become larger at the moment the shot is taken, and this reaction causes the flash to enter the subject's eyes and reflect off the red blood vessels at the back of the eye. Many cameras come with devices called "anti-red eye", but these are not wholly effective. They work by firing a series of small flashes before the shot is actually taken, the purpose being to reduce the eye's dilation. However, because there is a delay between composing or seeing the shot and actually taking it, the moment can pass and the animated expression can be totally lost. It is not really possible to reduce this problem if the flash is near the subject and is on more or less the same plane as the lens of the camera – only by having a separate flashgun, held to one side of the camera, can you eliminate the problem of red eye.

Another major benefit of having a separate flashgun is that it is far more powerful than a built-in flash. Many separate flashguns are of the dedicated variety: this means that your camera can read the amount of flash required through its TTL metering system. On most models you can tilt and swivel the flash head, enabling you to "bounce" the flash off another surface, such as a white wall or ceiling, in order to produce a softer, more diffused light.

Bounced flash

If you photograph your subject with direct flash, a harsh shadow can occur under the chin, as can be seen below left. However, if you bounce the flash, off a white ceiling for instance, the light is far softer, as is the case in the picture on the right.

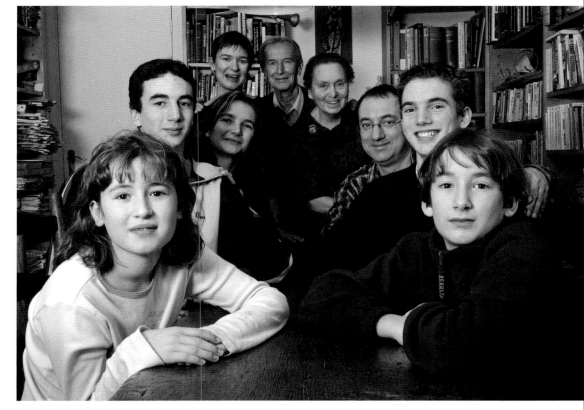

Right: I took this extended family group using bounced flash, which I directed at the ceiling. Sometimes this can cause shadows under the eyes, but some flashguns come with a supplementary flash under the main one. This can be used as a fill-in flash, as I did when taking the shot.

Right: When using SLR cameras there is a maximum shutter speed at which the flash will synchronise, usually around 1/125th second. If you choose a shutter speed that is faster than this, only some of your picture will come out correctly exposed. The faster the speed, the less the picture is correctly exposed, as shown here.

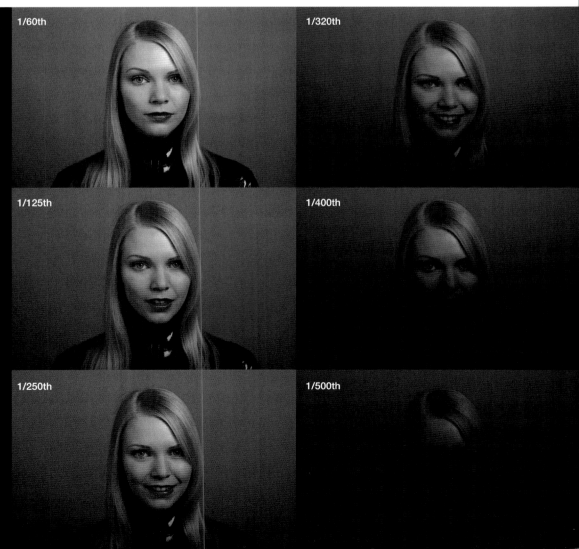

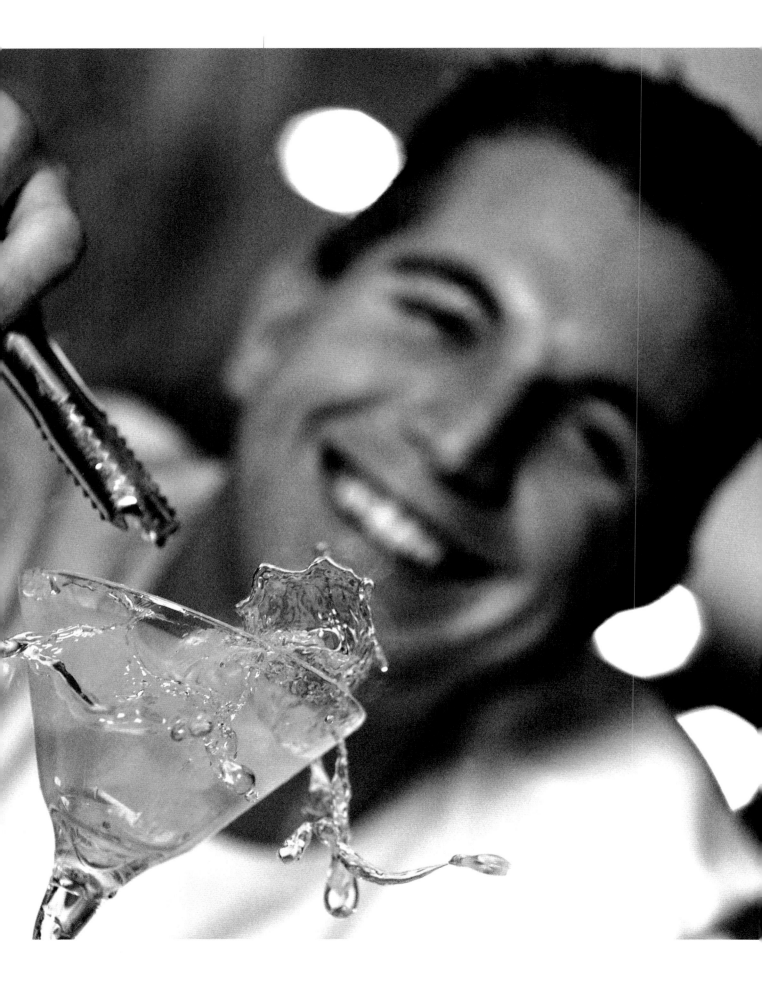

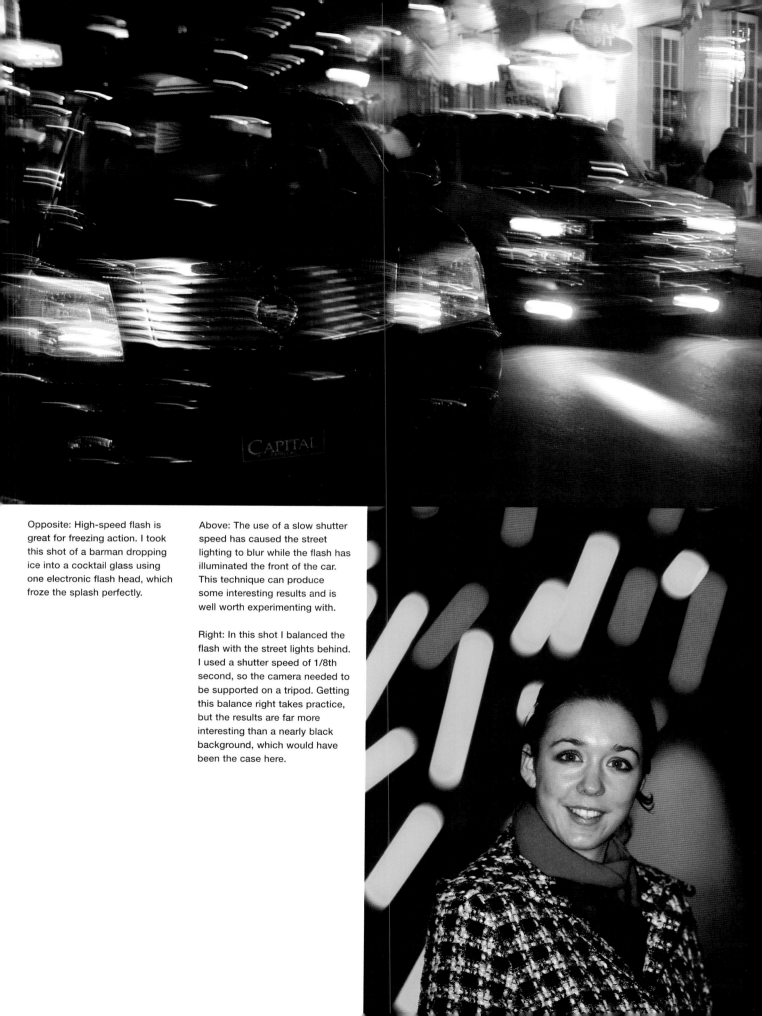

Opposite: High-speed flash is great for freezing action. I took this shot of a barman dropping ice into a cocktail glass using one electronic flash head, which froze the splash perfectly.

Above: The use of a slow shutter speed has caused the street lighting to blur while the flash has illuminated the front of the car. This technique can produce some interesting results and is well worth experimenting with.

Right: In this shot I balanced the flash with the street lights behind. I used a shutter speed of 1/8th second, so the camera needed to be supported on a tripod. Getting this balance right takes practice, but the results are far more interesting than a nearly black background, which would have been the case here.

Mixed Lighting

Although our eyes perceive most light as "white" light, film and digital sensors do not. The situation is aggravated further when the lighting comes from different sources, which can be daylight, tungsten, fluorescent or flash. When all of these are present in your shot, you need to balance out each with the others to make the shot as natural as possible, without a colour cast.

How this is achieved depends entirely on the mix of the different sources. With digital cameras you can alter the white balance setting to auto, but this can sometimes create problems of its own when it comes to getting a first-class print.

The simplest form of mixed lighting is where daylight needs to be balanced with flash, for example in an interior where you want to retain the detail that can be seen through a window or door, and still have the room evenly lit. To do this, you need to work out what the flash exposure is.

Remember, it is the aperture that is important here: if this is f11, for example, you need to take a reading of the daylight coming through the windows that matches this. When the meter shows the same reading, f11, then you can see what shutter speed is required – if it is 1/15th second, you next need to set this on your camera.

If the room you are photographing is lit by fluorescent light, you need to use a light-balancing filter on the camera to correct the green cast that would otherwise appear on your photographs. However, if the fluorescent light is insufficient or would cause hot spots if used as the only light source, you need to balance it with flash.

Because flash is balanced with daylight, you should cover the flash heads with a light-balancing gel, which turns the flash light green and matches the fluorescent light. The filter on the camera then corrects the light from both sources, making your finished shot evenly balanced and without any discernible colour casts.

A similar procedure can be followed if you are balancing tungsten light with flash – in this case you do not require a filter over the lens, but you need to gel the lights to convert them to the same colour temperature as the tungsten light.

Above: I had to deal with three different light sources in this shot: daylight coming in from the windows on the right, tungsten from the room lights and the flash with which I lit the subject. As the flash and daylight were the dominant sources, I set the camera's white balance to the K setting at 5,200° K.

Above right: This is a similar shot, with daylight from the windows, tungsten from the room lights and fill-in flash, but there were far more people to light. I decided to go with the tungsten light and put an orange gel over the flash to balance it with the room lights.

Opposite: Here, the lighting was a combination of daylight and tungsten. I decided that the daylight was the dominant source and used the camera on a tripod as it required an exposure of 4 seconds. Although the tungsten-lit parts of the shot are very slightly orange, I feel they are acceptable.

Overleaf: I took this picture of the engines used to power the Saturn 5 rocket in a combination of daylight and fluorescent light. Because the fluorescent light was the dominant source, I set the camera's white balance to that setting. The result is a very evenly illuminated scene.

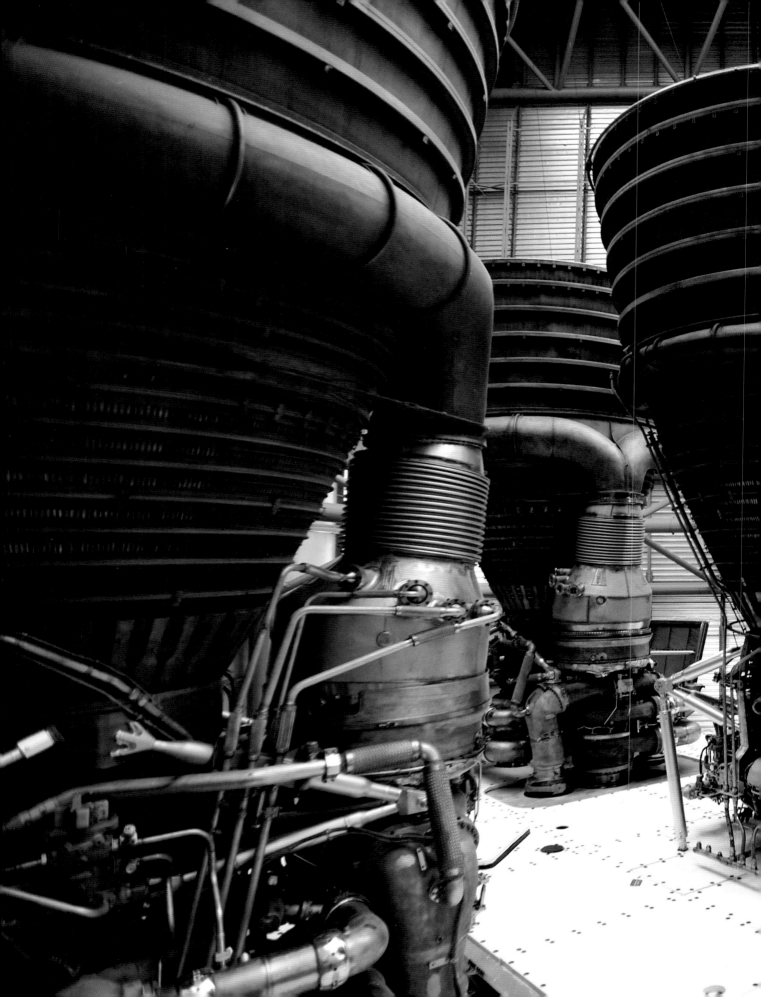

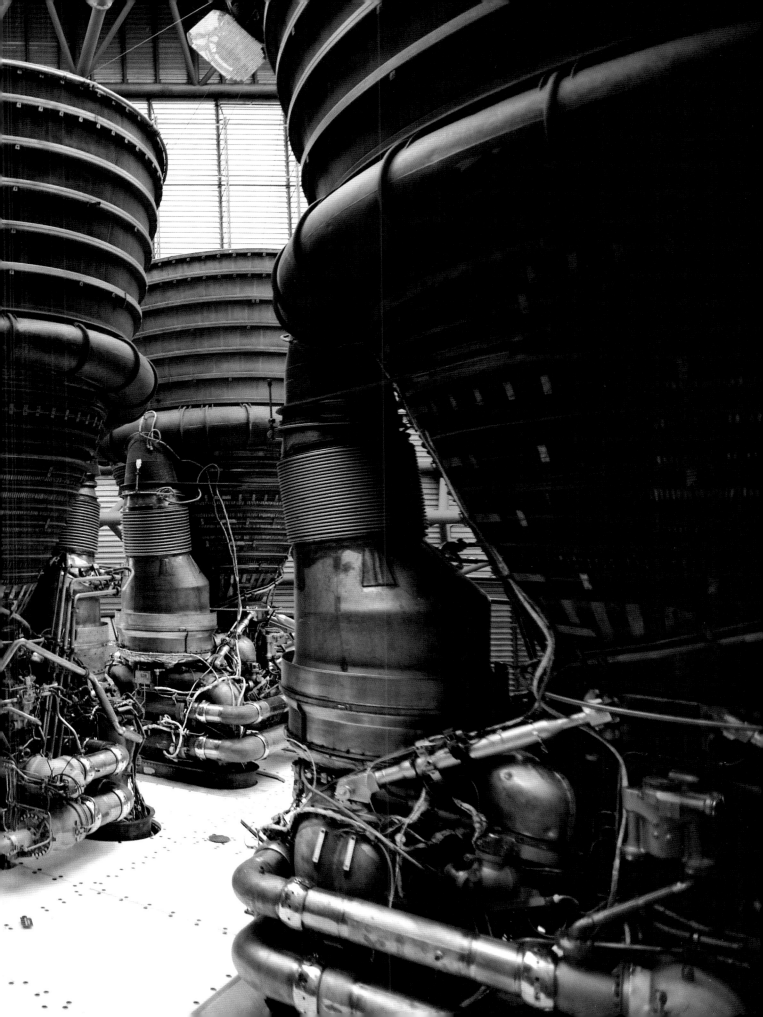

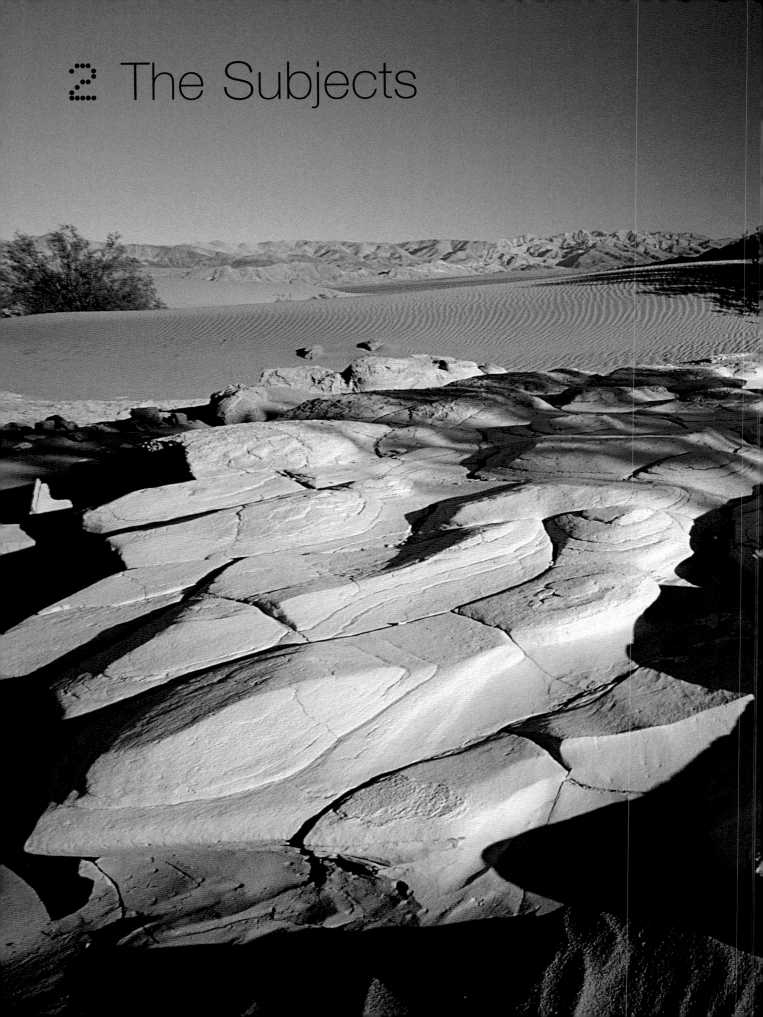

Daylight Portraits

As we have seen, although it can seem the easiest light in which to take portraits, daylight can be full of problems – in bright sun, harsh shadows can occur in your subject's eyes and under the nose and chin, and the intensity of the light can make people squint and screw up their eyes.

Another problem is contrast. If you are shooting in an area of bright light compared to the background, which may be in deep shadow, the overall effect is likely to be highly unattractive. In addition, there is always the possibility that the subject can come out overexposed, as the camera's metering system may take most of its reading for the dark background.

If the sun is very bright, it can be best to move your subject to an area of overall shade where the light is more even and it is more comfortable to pose in. On the other hand, you can turn your subject so that they have their back to the sun, which gives a pleasant backlight to their hair and can look highly attractive in a photograph. The problem with shooting in this way is that flare can be caused by the sun falling on the lens, so you

should use a suitable lens hood. (In any case, a hood should be fitted to the lens at all times.) If you shoot this type of shot, take your exposure reading from close in on the skin – if you stand back to take your reading, the chances are that the meter takes most of its reading from the bright sun and your subject comes out underexposed, if not a silhouette.

If your camera has a spot metering mode, taking the reading is made that much more easy. Be careful not to cast your own shadow over your subject when taking the reading, as this can also cause overexposure. Alternatively, if your camera has a built-in backlight mode, this should give a reasonably accurate reading. You may also want to use fill-in flash (see pages 126–129) or a reflector (see pages 130–133), either of which can help to add vitality to your subject's skin tones.

When shooting a group of people, be careful that shadows caused by one person do not fall across the face of another. Mount the camera on a tripod, so you can check the group each time you move someone to a different position.

Above: When taking portraits in daylight many people position their subject facing the sun (left). This can cause ugly shadows and make the subject screw up their eyes and squint. Turning the subject round with their back to the sun eliminates this problem and creates a far more pleasing result (right).

Opposite top left: An overcast day can sometimes be an asset when photographing outdoor portraits. For a start, the light is very even so there are no harsh shadows, and it is more comfortable for your subject. Because the light is diffused, you can position your subject in almost any area.

Opposite top right: For this shot of a dancer dressed in traditional costume, I used a 70mm telephoto lens and chose a wide aperture. This put the background far enough out of focus so as not to be a distraction, hence the emphasis is on the face.

Opposite bottom left: When shooting portraits of people wearing hats outdoors, shadows can be caused by the brim or the peak of the hat. Here, I used a reflector to bounce light back so that the shadow was eliminated.

Opposite bottom right: In contrast, I liked the shadow that the hat made across the girl's face. If the brim of the hat had been solid it would have cast an ugly shadow, but the mesh-like material enhanced the lighting for the portrait.

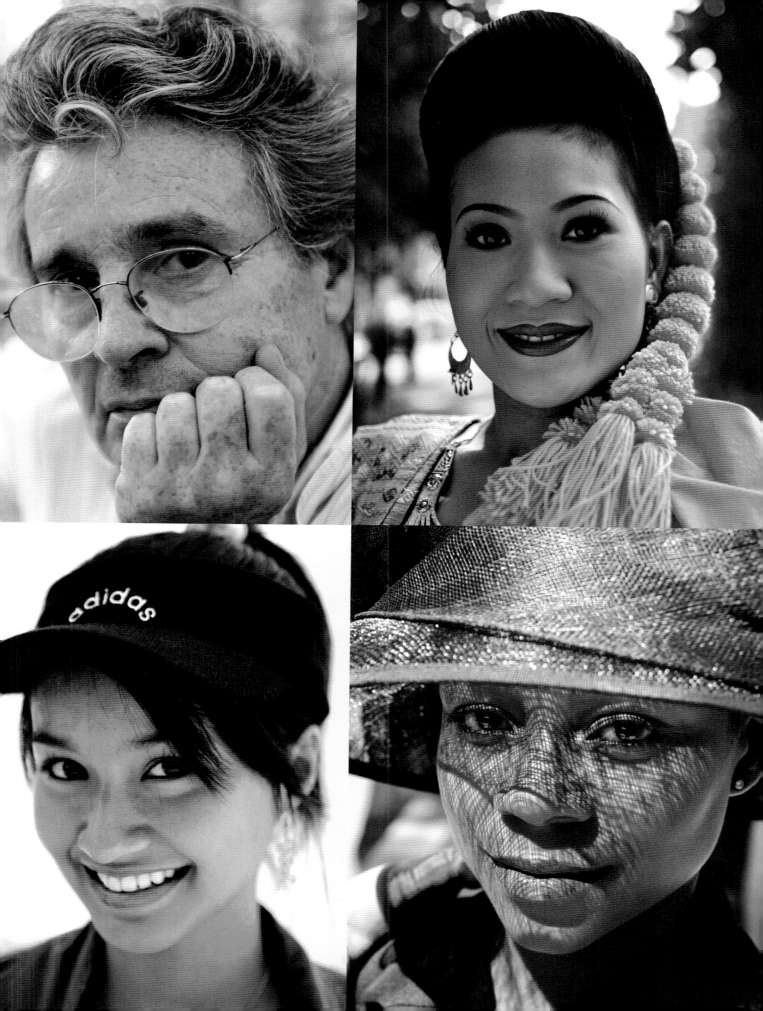

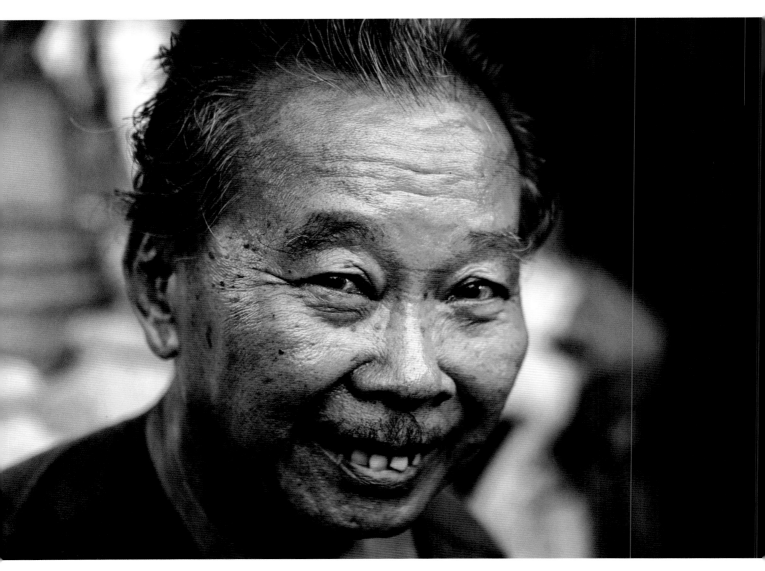

Above: This man's face is full of character. I positioned him in an area of shade and used a 200mm telephoto lens with an aperture of f2.8. This put the background well out of focus, making him the centre of attention.

Opposite: I used the same lens for this portrait, but stopped the aperture down to f8. This made more of the background sharp, which gives a sense of place, but not enough to be a distraction. The girl's face contrasts well with that of the old man.

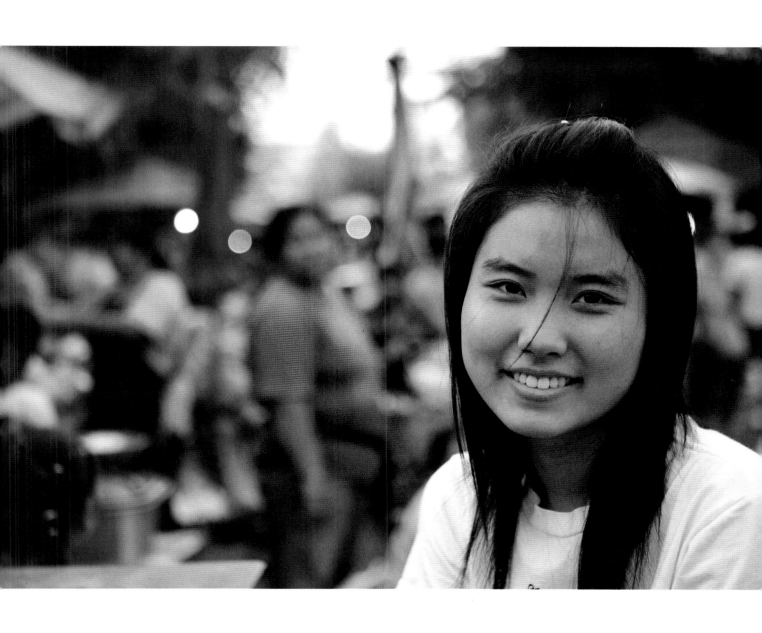

Available Light Portraits

"Available light" refers to the light that the photographer can use without having to supplement it with an additional light source. The benefits of using this type of light are that your shots can look wonderfully atmospheric, and the setting of a particular mood can be much easier to achieve than with flash.

The most important point to remember when using available light is that the light levels are likely to be quite low, so when using a fast film, the grain and contrast are more prominent than with a medium or slow film. You can use this to your advantage, as you can by "pushing" a slower film. You can do the same when shooting digitally, where the use of a higher ISO setting increases the noise, the digital equivalent of grain.

For shooting in available light, it is very useful to have some type of reflector, which can be as simple as a piece of white card or paper, a white sheet or towel, or even a newspaper or a book. If your reflector is coloured, even slightly, it can cause a cast on the skin of your subject. Many custom-made reflectors are double-sided, with white on one side and perhaps gold on the other (see pages 130–133).

In the northern hemisphere, sunlight never shines directly through the window of a north-facing room. This means that you can use a diffused light that gives beautiful soft shadows. This is the light favoured by many painters in the past, whose studios were always built with north-facing windows. (In the southern hemisphere, it is a south-facing window to be on the lookout for to achieve the same quality of light.) If the light is too cool in these conditions and you are shooting in colour, it can be beneficial to use a warm-up filter such as an 81A.

Where the light is more directional, for instance where it is shining quite brightly through a window, you can diffuse it by placing tracing paper over the glass or by hanging a thin fabric such as muslin in front of it; if you have a proper photographic reflector made of a diffusing material, use this to soften the light. At the same time you may want to "flag" the light by blocking some of it off with curtains or black card or paper.

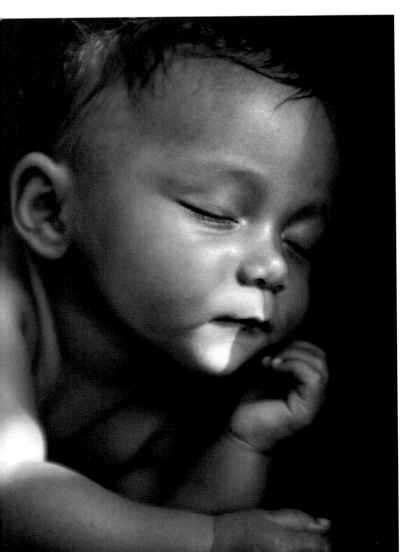

Left: This baby was asleep in her pram when I took this shot, so I could not change the situation and had to use the available light. I particularly liked the way little pools of light fell across her face and arm, which added to the shot rather than detracting from it.

Opposite: I photographed this girl standing with her back to a window fitted with a venetian blind. This made an interesting backdrop; by using a soft white reflector, which she held, just enough light was bounced back to illuminate her face.

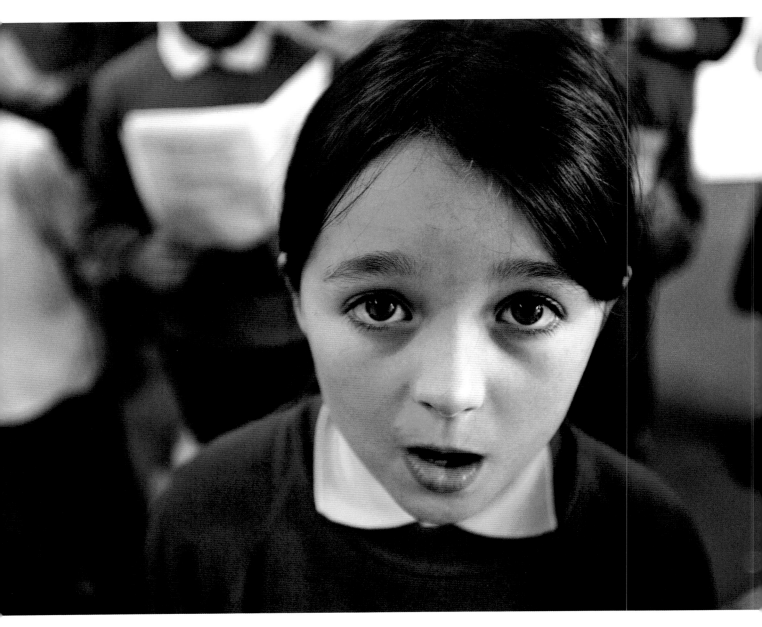

Above: This girl was singing in her school choir. I used the fluorescent hall lights, as opposed to flash, which might have distracted her and the other pupils. I set the camera's white balance to the fluorescent setting, and the result is a perfectly balanced shot.

Opposite: I used the available light coming in from the window that can be seen in the background of this shot. Instead of using a reflector, I deliberately let the background go light while I exposed for her face. This created a very soft and romantic light, which would not have been the case if the lighting had been evenly balanced.

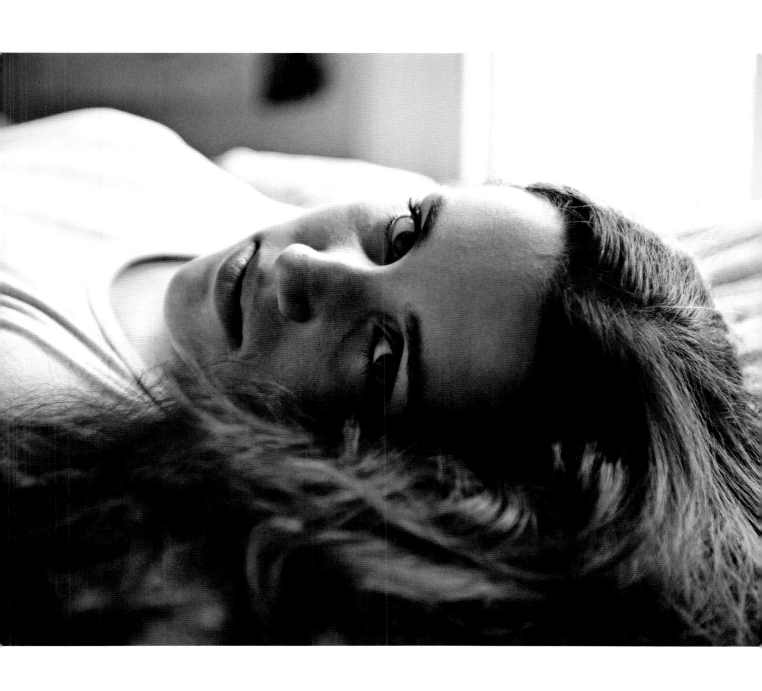

Lighting the Body

No matter what camera equipment you use to photograph the body, your greatest consideration is the quality of light in which you intend to take your shots. Whether artificial or daylight, the way you control the light determines whether pictures are striking or mediocre.

Using artificial light, such as a single studio flash unit, you can achieve a huge variety of effects. A single light, for instance, can be placed almost directly behind your model to draw the most revealing line along the contours of the body. The same light brought further round to the camera so it is almost directly to one side of your model, produces strong shadows. With careful positioning, such a strong directional light can be used to emphasize a variety of different body areas, from a woman's breasts to a man's toned stomach muscles; and when it is brought even further round so that it is close to the camera and directed through a diffuser, an almost shadowless soft light is the result. When printed as a high-key picture, the result of the last example can be a highly romanticized image of sensuality.

If you are using available light indoors, such as daylight coming through a window, you can still control the quality in much the same way as you can with studio lights; the only difference is that sunlight is continually on the move, so you have to shoot that much quicker to take advantage of the optimum conditions. If the light coming through the window is too harsh, you can diffuse it with a material such as muslin or tracing paper; tough frost is a purpose-made photographic material for this situation. Reflectors also play a key roll in lighting the body when using available light, but remember that any reflector that isn't white causes a colour cast; while this can be used to effect, it can also ruin a good shot.

When shooting the body outdoors, controlling the light is not so easy and you need to give consideration to the location in which you shoot: if this is in an entirely open area, you must take care that any harsh shadows do not look ugly. In contrast, an area of overall shade can be more flattering, especially if the light is filtered through trees, creating a dappled look.

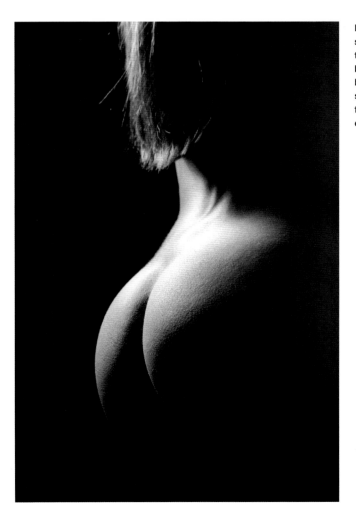

Left: For this shot I placed a single flash head almost behind the model, pointing at her. This highlighted the curves in her body and accentuated the shape. Often it is the simplest forms of light that give the most effective results.

Opposite: This is another shot lit with a single light source. I placed the flash head directly above the model and shone it straight down. This created interesting shadows on her body and gave the shot an overall feeling of symmetry.

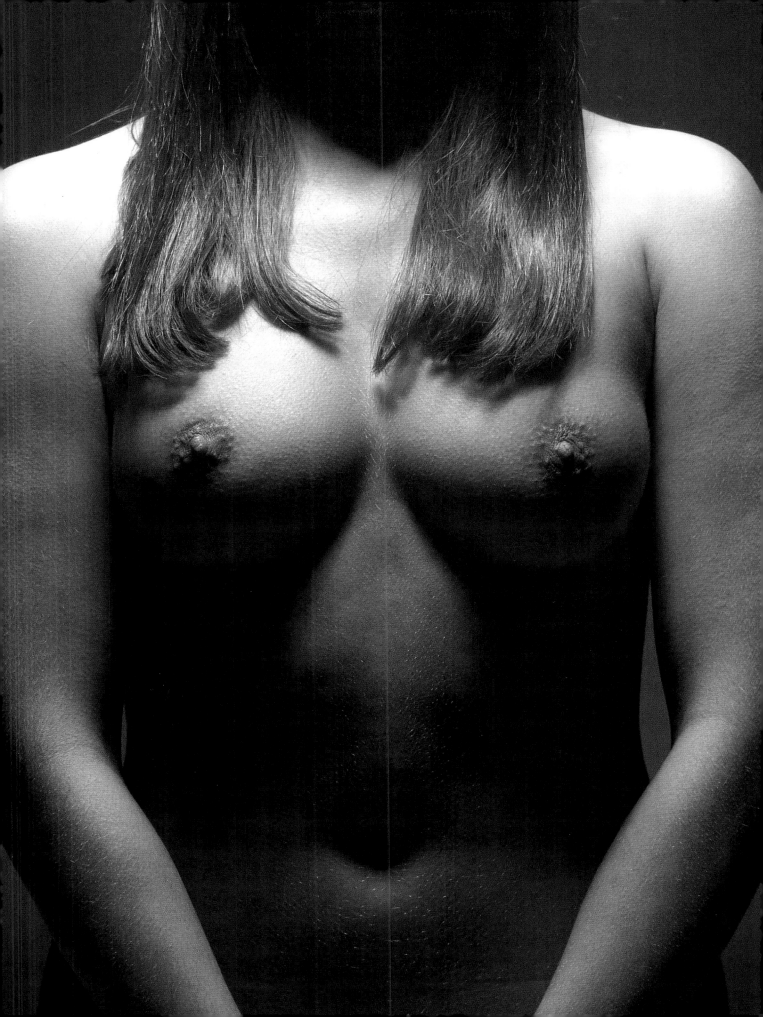

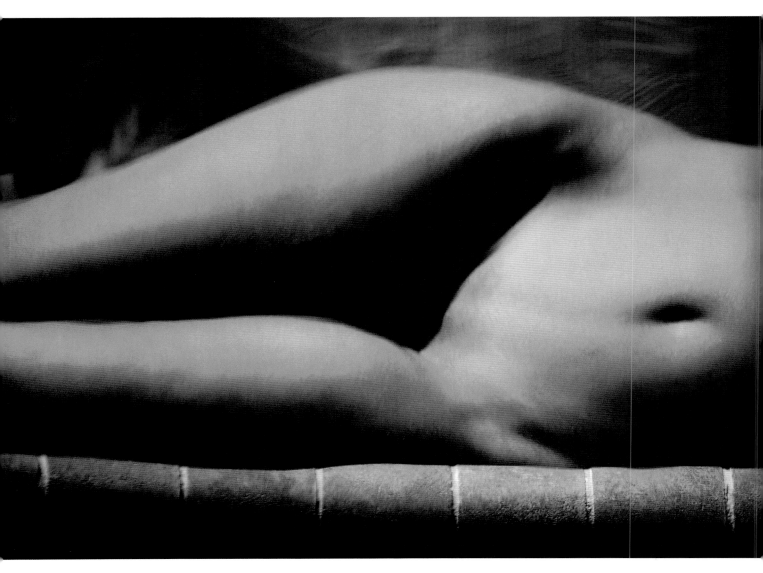

Above: I took this shot by the side of a swimming pool and the body was reflected into the water. I then inverted the picture so that it now appears that she is lying on her side and the diffused reflection gives the shot a romantic feel.

Opposite: By using a 16mm wide-angle lens I exaggerated the shape of this man's body. It is reminiscent of shots that the late Bill Brandt used to take, the main difference being that I shot this on a Canon 1DS, while he used a 5 x 4 Gandolfi camera.

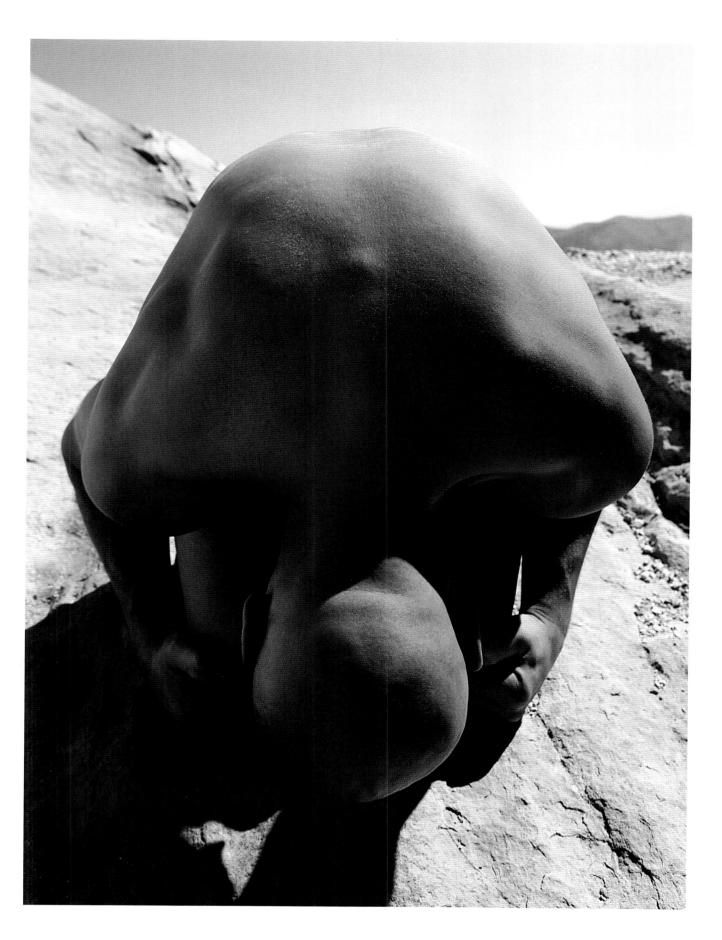

Landscapes

All too often we are inspired to photograph a beautiful landscape view and are then disappointed by the results once the shots have been printed. This can frequently be traced to the lack of thought given to the light and how it varies from one portion of the photograph to another.

The most common failure with landscape photography is the sky. When a sky looks very dramatic at the time you see it, yet completely lacks cloud detail in the print, this is because the sky, even when clouds are quite dark and ominous, can be as much as three stops different from the exposure required for the land that makes up the rest of the shot. However sophisticated your camera, it cannot balance this discrepancy in exposure.

A graduated neutral density filter cuts down the exposure required for the sky, allowing detail to be recorded in the landscape. These filters come in different densities and can be doubled up for a really dramatic effect. If you find yourself in a situation where you do not have the appropriate filter, you can enhance the image later on a computer.

Another reason why landscape photographs can be disappointing is the lack of thought paid to the foreground. This can be improved by simply taking into consideration the time of day when you take your shots. If this is early in the morning, when the sun has just risen, long impressive shadows, cast by trees, shrubs and rocks, stretch across the foreground and add drama to your picture. However, if you take the shot from the same spot at midday, when the sun is at its highest and the shadows are short or non-existent, the result is likely to be flat and boring. At the end of the day, late-evening skies can produce wonderfully coloured skies that are more subtle than a full sunset and infinitely more interesting than a midday sky.

Always be on the lookout for different lighting conditions that can occur quite suddenly and can totally alter the feel of a landscape photograph, for instance a situation where dark, almost black, storm clouds appear as a backdrop while the sun still shines brightly on the foreground. To get this type of shot needs quick thinking, as the conditions can change rapidly.

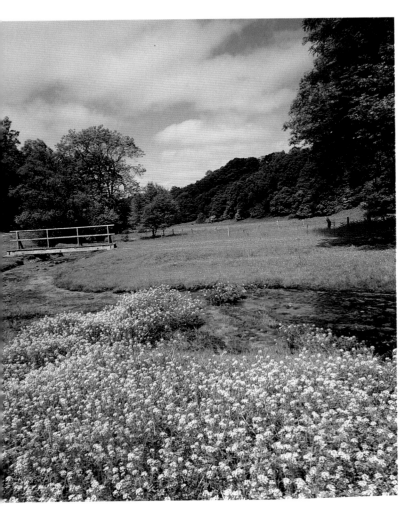

Left: Many landscape photographs fail because too little attention is paid to the foreground. Here, I positioned myself to take full advantage of the spring flowers that spread out like a carpet at my feet. I pointed the camera slightly downward and used a wide-angle lens to fill the foreground.

Opposite top: While heat haze can often be a problem in landscape photography, I managed to make it work to my advantage in this shot. The late afternoon sun hung like a disc in the sky and was muted enough for me to be able to take the shot looking directly at it.

Opposite bottom: For this early morning shot I chose a 28mm wide-angle lens and placed the building in the middle of the frame. Although this positioning is often frowned upon, as it breaks the conventions of what is thought to be good composition, I think it works well, as it shows the building to be completely isolated in the landscape.

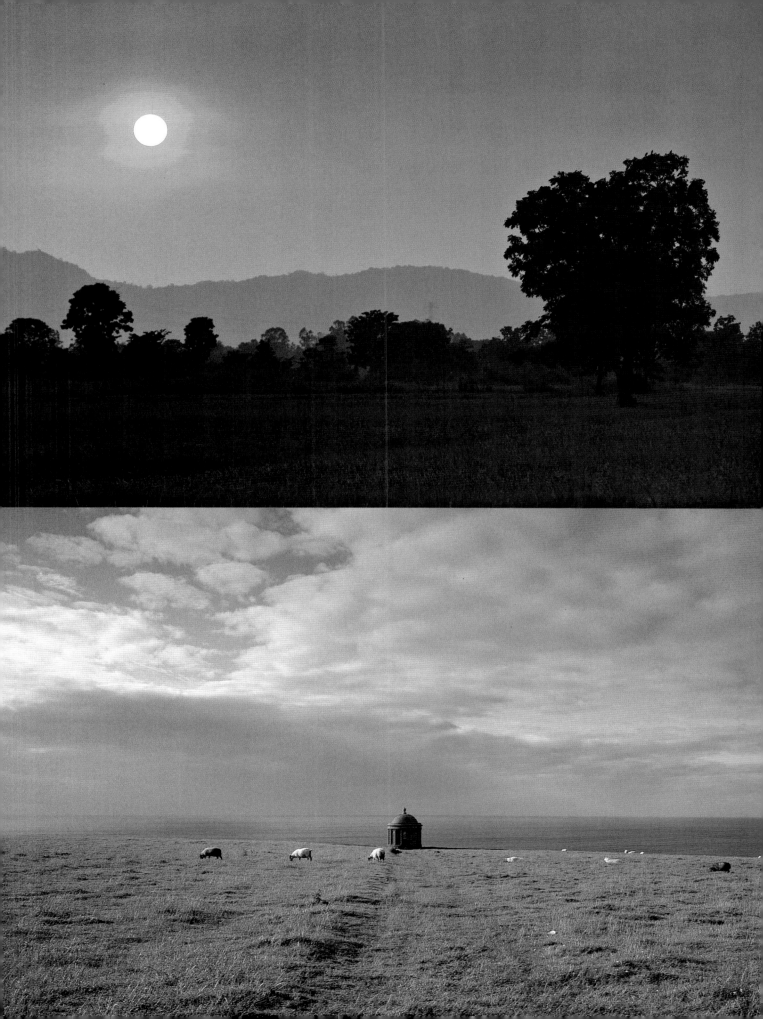

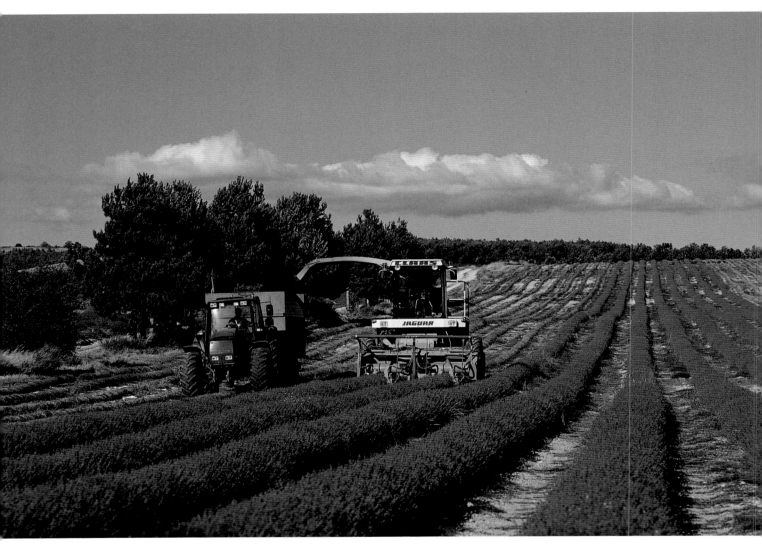

Above: I shot this in Provence one summer evening when the light was beginning to sink low. The lines of lavender provide good perspective and a strong sense of colour. I had to use a shutter speed of 1/250th second so that the tractor and combine stayed sharp as they came towards me.

Opposite: I am always on the lookout for natural lighting effects, and I struck lucky when I walked down this country road in Tuscany. The sunlight filtered through the trees, making attractive patterns on the surface of the road as it stretched away into the distance.

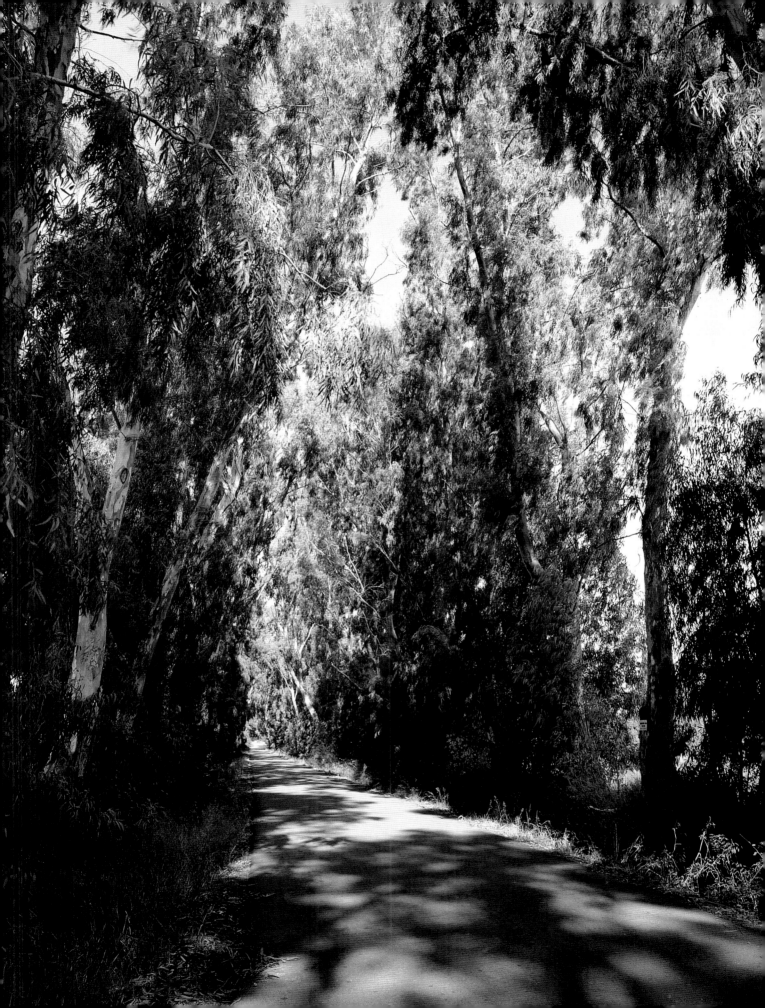

The Weather and Light

There are a few places in the world where the weather is constant all year long and where you can, with reasonable certainty, predict what the weather will be like at a given time of year. However, there are many more places where the weather is totally unpredictable – and because it can change dramatically in a short space of time, you need to be prepared to take full advantage of these variations.

There are many opportunities for great pictures in rain, fog and mist, snow and frost. While it is difficult to take effective pictures in pouring rain, there are other aspects of wet weather of which you can take advantage. For example, distant clouds from which you can clearly see rain falling can look dramatic if caught in the right light. You may need a telephoto lens for this type of shot if the rain clouds are some distance away; if the rainstorm is quite near, a wide-angle lens used from a low viewpoint can make the sky look quite foreboding. Whether you are shooting on film or digitally, a graduated neutral density filter can help to increase the drama of dark storm clouds.

After the rain has stopped, puddles and other wet areas can provide interesting reflections that can look very effective in bright light. Study such reflections carefully, as it is surprising how just a few steps backwards or forwards can make all the difference to the reflection and how much you see of it. When taking this type of shot, focus on the reflection and not on the top of the water; the latter can be easily done when your camera is set to auto-focus.

Unless mist and fog are particularly thick, it is possible to get some very atmospheric pictures in these conditions. As with reflections on water, the auto-focus on your camera may have trouble focusing, so it is usually better to use the manual focus setting. The light in these conditions is probably going to be quite low, so a tripod is an asset. At the same time, when taking shots in snow and ice, don't be fooled into thinking that there is more light than there actually is; with so many bright and reflective surfaces around, the camera's metering system can quite easily underexpose your pictures.

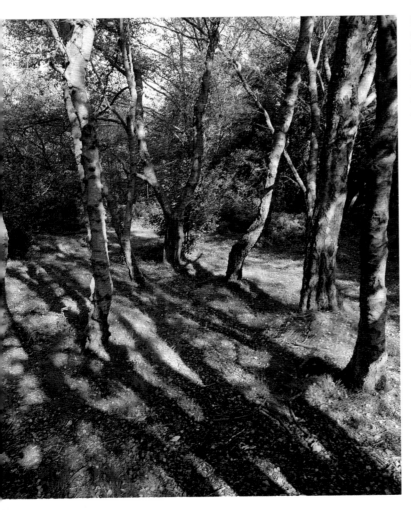

Left: When the weather is clear and the sun is shining brightly, I always try to find strong shadow detail that evokes a sense of place. Here, I shot looking into the sun. The shadows of the trees streaked towards me, forming a strong graphic pattern on the ground. This is a good example of light and shade.

Overleaf: As with so many shots where you are trying to emphasize the weather, you need to be in a position to act quickly. This shot was taken in Florida: a storm was beginning to gather momentum and was racing across the sky as I drove along the road. I pulled up as quickly as I could and got the shot before the whole sky turned black.

Right: Rainbows look great in photographs and are another reason why carrying a camera with you at all times is essential. This one, arcing over London's St Paul's Cathedral and the City, adds a touch of colour to the darkness of the stormy sky.

Below: The rain clouds hang heavily over the urban development and look as though they are about to burst into a torrential rainstorm. The shot has an aura of gloom about it, and the feel is of urban desolation.

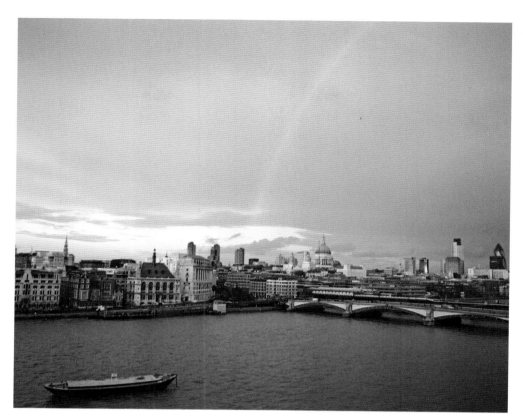

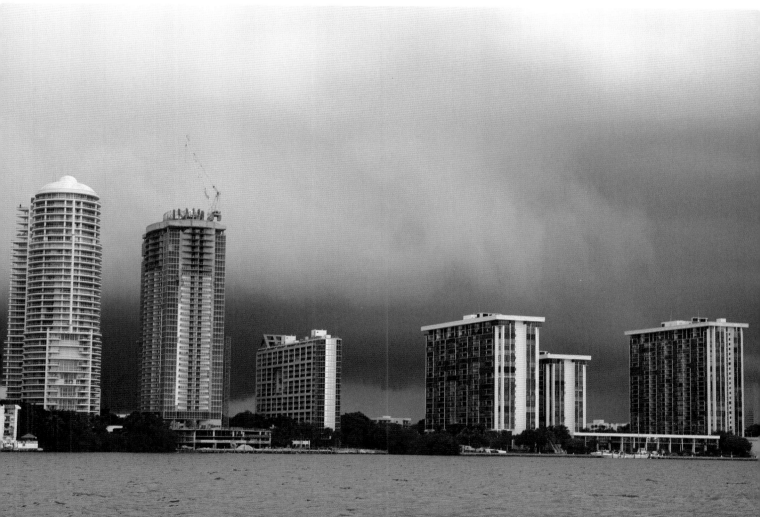

The Time of Day

Light changes rapidly, from the minute the sun rises to the time it sets. Even half an hour before or after these times, skies can take on a different feel, and providing you have a tripod to keep the camera steady, you can take great shots within this period. Because the light changes so rapidly in the early morning, you need to be prepared in advance if you are to take full advantage of the range of different colours that can occur in the sky: no two days are the same, and a sunrise lost today may not look at all the same tomorrow.

Taking all this into account, it is more than likely that you need to get up before the sun has risen, as it is at this time that the colours of the sky change most subtly. Of course there are areas where it is possible to reasonably predict what the weather will be like, such as the Mediterranean or the west coast of California in the summer months, but in more northern countries, a clear and haze-free dawn one morning can be followed by a misty, murky one the next.

When shooting digitally, do not set the camera to auto white balance, because any atmosphere and warmth of the light can be lost with the camera on this setting. If your camera allows you to choose the Kelvin setting, this is preferable – I would set it to 5,200° K. In fact, there are very few situations in which I would use auto white balance, because in many cases this setting has a tendency to remove colour casts when it is these very casts that provide the mood of a picture.

When shooting in the summer months, the best time to emphasize a blue sky is before midday. During this time, with the sun at its highest point in the sky, shadows are short and skies can look very flat. In addition, if you are using a polarizing filter to enhance a blue sky, shooting a couple of hours either side of midday is the optimum time – remember that such a filter cuts the transmission of light entering the lens considerably, by as much as two stops, or the difference between 125th second at f11 when not using the filter, and 125th second at f5.6 when you are.

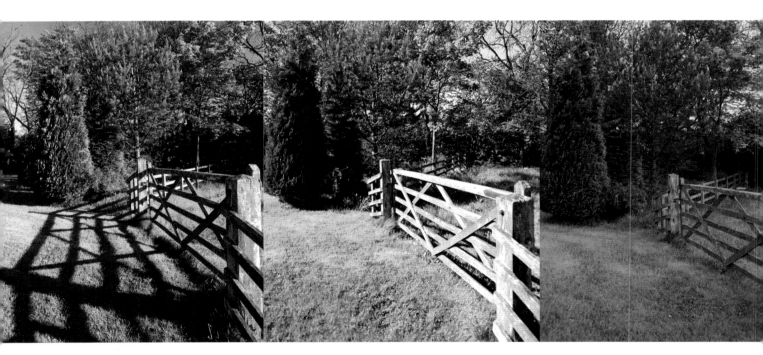

Above: These three shots show how light changes with the time of day and how the feel of the subject can change with it. The picture on the left was taken early in the morning, when the sun created an interesting shadow of the gate on the field. By midday this shadow had disappeared, and although the gate was brightly lit, it lost the impact of the first shot. By late afternoon the sun had moved off the gate completely, and the view now looked quite dull.

Choosing the time of day to take your shot is just as important as viewpoint, composition and the choice of equipment.

Opposite top: The setting sun provides a perfect backdrop for this shot of a motorway as it wends its way through the countryside. Because I did not want to lose the detail in the sky, I used a graduated neutral density filter to even up the exposure between the sky and the foreground.

Opposite bottom: I had to use a shutter speed of 5 seconds when taking this picture of the Thames in London at dusk. This meant that the traffic on the river and the London Eye are blurred, but I think it adds to the sense of activity and gives the shot an air of realism.

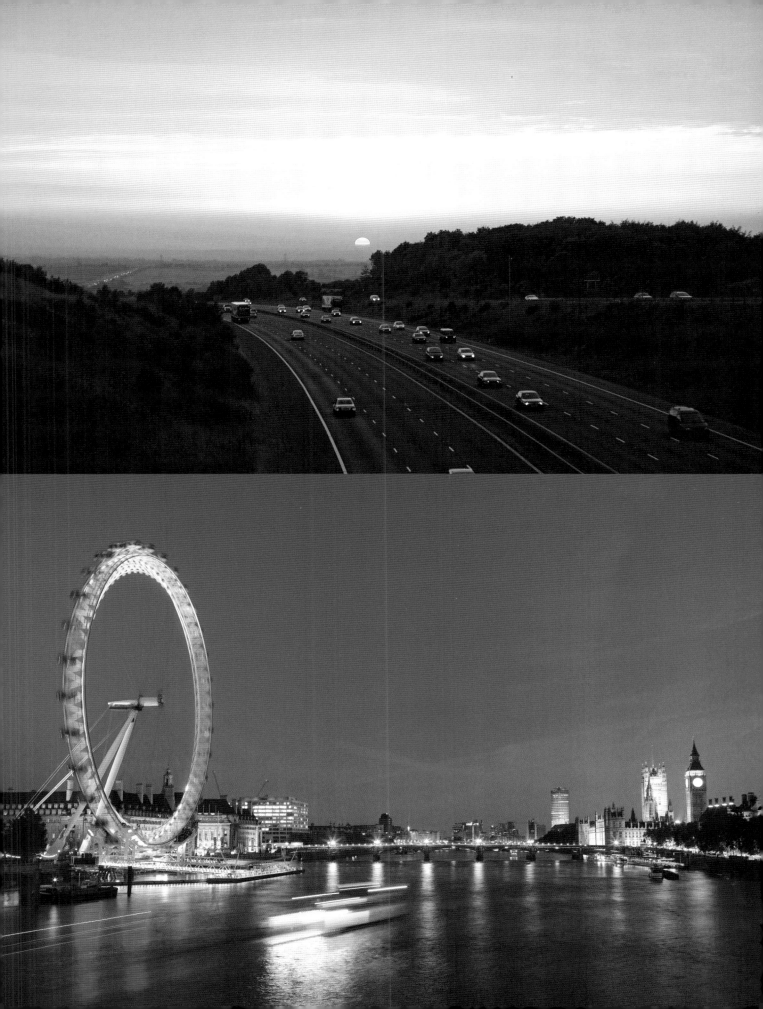

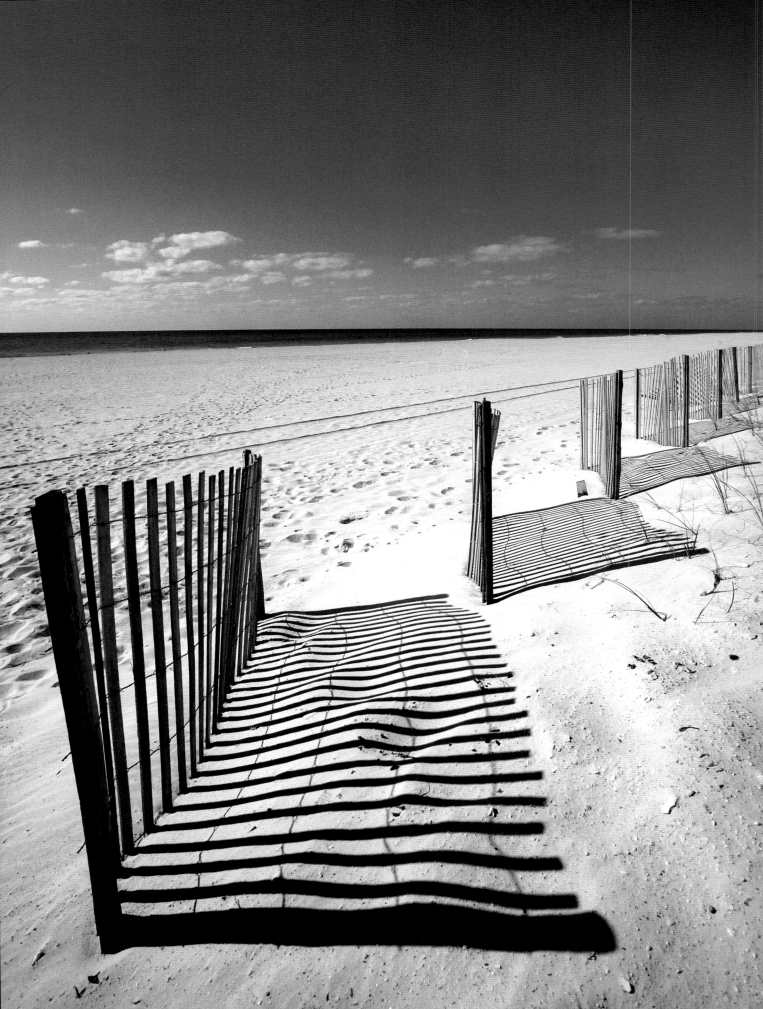

Opposite: This line of windbreaks was shot early in the morning, when the sun was still quite low in the sky. The shadows form an equally interesting line as they stretch along the sea shore. A polarizing filter was used to retain and enhance the blue of the sky.

Above: This young Ghanaian boy was photographed in the late afternoon and he is bathed in a warm light. I deliberately used a wide aperture and focused on his eyes. This has isolated him from the rest of the group who are slightly out of focus.

The Time of Year

The changing seasons offer the committed photographer a year-long variety of natural phenomena and the chance to observe in detail how sunlight varies from one period of the year to another.

Spring provides an abundance of subjects to photograph, and the light can be bright and crisp, without any haze. As so often with landscape photography, it pays to be up before the sun has risen – partly because there are few people around, but mainly because the low morning sun can filter through trees, creating dappled light or casting long, interesting shadows. The sun often rises quite rapidly, and in minutes the quality and feel of the light can alter dramatically and the scene that first attracted you can all but disappear.

Although the majority of us look forward to summer, this time of year can be full of problems when it comes to taking photographs. For instance, the sun can become so hot that a heat haze builds up, making photographs of landscapes look flat and dull with skies that are almost grey in appearance. If the weather has been like this for some time, haze can persist even in the early morning and remain until a thunderstorm and rain clear the air. If haze is a problem, look at the scene in a different way, perhaps going in close and cropping tightly.

What really makes the colour of autumn leaves look so brilliant is the way in which they contrast with one another, or against a clear blue sky. To this end, bright early-morning sunlight is essential, as nothing is more disappointing than shooting autumn foliage in overcast conditions. When shooting close-ups of leaves, it is essential to have them backlit by the sun so that all their veins and colour stand out.

Because snow reflects so much light, it can fool the camera's exposure metering system into thinking that there is more light than there actually is. If you point the camera at a snow-covered landscape, trees or buildings to one side of the frame may come out underexposed, as the meter has read for the highlights and underexposed the shadows, the trees or buildings. Take your reading from an area of mid-tones instead.

Above: By getting down low I filled the left hand side of the frame with the nearest corn sheaves and had the others stretch away into the distance. This created a good sense of perspective, enhanced by the use of a 28mm-wide angle lens.

Above right: The crisp, bright light in this shot is typical of a late spring day. The field in the foreground is bursting with flowers and makes a good contrast to the rugged hills in the background and the bare trees that fringe the foothills.

Opposite: I used the autumnal colours of these trees to frame the left-hand side of the picture while positioning myself so that they could also be seen stretching away into the distance. Because I wanted the picture to be sharp overall, I used a small aperture and a slow shutter speed, which meant mounting the camera on a tripod.

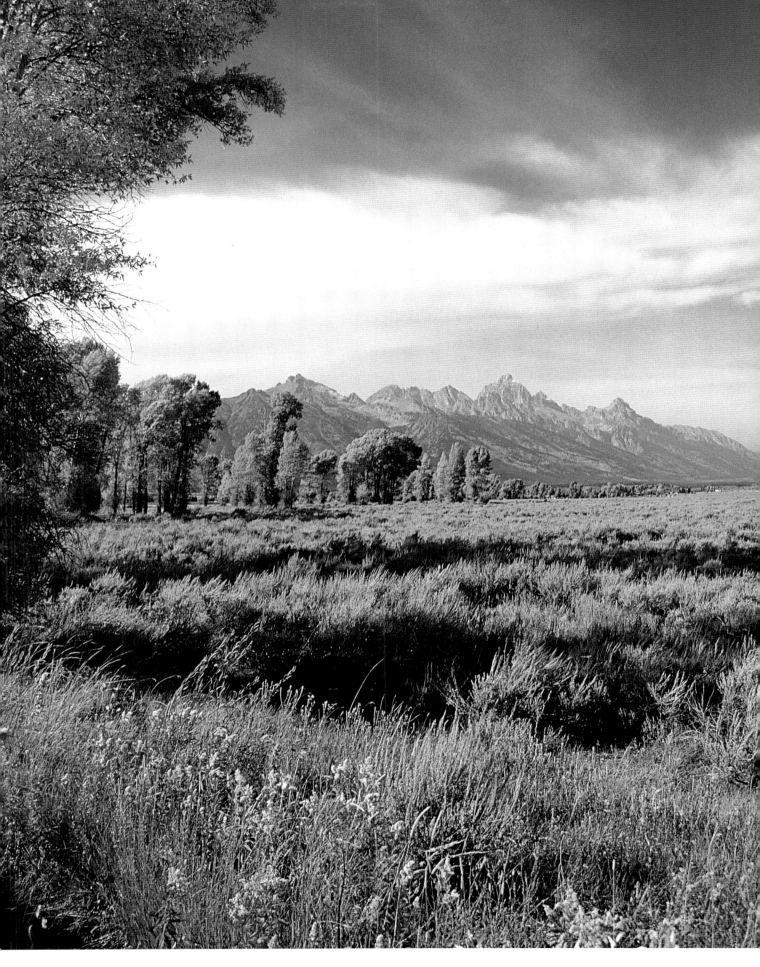

Above: This tranquil spring scene was shot in the south of France. The picture bursts with new growth, and it would be difficult to mistake the season for any other except spring. I used a 150mm lens to crop in tight and keep out unwanted detail.

Opposite left: In the majority of cases, it is best if the sun is shining when taking snow pictures, as without the strong shadow detail this produces, shots can end up looking flat and dull. Here, the sun created strong shadows on the snow, which contrasted well with the blue sky.

Opposite right: By using an extreme wide-angle lens of 17mm, I managed to get virtually this whole scene in focus. I deliberately took a low viewpoint to give the effect of the ground appearing to sweep away from the viewer, thus giving great depth to the picture.

Lighting Interiors

A common mistake that many photographers make when taking pictures of interiors is assuming that because the built-in flash goes off, the picture must come out.

Even when a room is relatively small, built-in flash can often make the final image look harsh and bright, with any foreground detail washed out. At the other end of the scale, the power of built-in flash is totally inadequate when photographing large spaces, such as a gallery in an historic house or the interior of a church. Even if you override the flash and use the available tungsten lights, you may find that these cause hotspots or, when shooting on daylight film, that your shots come out with an orange cast. In available light the exposure is likely to be long, so a cable release and tripod are essential.

Once you have selected your viewpoint, you need to consider which lens to use. Although a wide-angle lens might appear the best choice because it can capture more, this can have the effect of "stretching" your shot so that it looks as if it was taken through the wrong end of a telescope, leaving the background detail lost in the distance. However, a wide-angle lens does have its uses, especially if you want to look straight up, to show the detail in a decorative ceiling, for example. A shift or parallax correction (PC) lens eliminates converging verticals and means you don't have to correct these later on a computer.

Once you have chosen your viewpoint and lens, consider the amount of light available and the type. Is the scene well-lit, with daylight coming from side windows. If so, is the light even? For instance, when taking a shot looking down a church nave, with windows on each side, it is unlikely that the daylight comes evenly through all the windows, which means that one side of the interior may be in deep shadow, while the other may be bathed in strong sunlight. Your only remedy here is to fill the shadow area with flash, or wait until the sun has moved to see if the light is more evenly distributed.

If you are shooting a room with lots of tungsten light, you may still have to supplement this with flash. The trick here is to get an even balance (see pages 60–63).

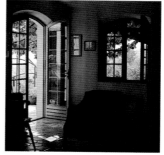

Left and above: When taking pictures of interiors, it is sometimes advantageous to be able to see the exterior through the windows and doors of the room, as is the case on the left. However, this is only possible if you balance up the two different exposures using fill-in flash or some other additional light source. If you just expose for the exterior, then the room will come out underexposed, as above.

Overleaf left: I liked the juxtaposition of these two interiors. On the left, the interior of Lloyds of London was taken from several floors up, looking down onto the floor below. It was lit by a mixture of fluorescent light and daylight.

Overleaf right: The interior of the cathedral of Palestrini in Italy was lit by the daylight coming in through the windows, and I took the shot looking up to the ceiling.

Above: I took the interior of this shop using the available light. This was primarily the fluorescent light that can be seen hanging from the ceiling. However, this has given an even spread of light. If I had taken the shot with on-camera flash the background would have come out quite dark.

Right: I took this shot looking straight up the interior of this building in Siena. It was lit by the available daylight coming in through the top window. Although it is quite dark the spiralling floor pattern makes an interesting shape and its depth is accentuated by the use of a wide angle lens.

Lighting for Exteriors

In addition to the architecture in your own area and buildings you might see travelling to and from work or in different regions, it goes without saying that architecture varies from one country to another, sometimes quite radically. Photographing buildings can provide many simple lessons in the way we look at pictures and give an insight into what many of us take for granted without really seeing.

Because buildings are meant to be permanent fixtures, the observant photographer is handed the opportunity of seeing them at different times of the day and night, in different lighting conditions and in varying weathers and seasons. If you are aware of the many changes such conditions bring, you can start to see ways of photographing buildings at the most favourable times and under the best possible conditions.

Learning to be discerning in this way helps you to look at other subjects and themes in a more critical manner, and to see details you might not have imagined existed. Daylight changes rapidly – as you can see if you watch a speeded-up recording of any outdoor view filmed from the same spot from dawn to dusk; there are astounding differences in shadow patterns and the changing colour hues as the sun rises and sets. These changes are at their extremes at dawn and dusk, with skies seeming to alter their colours by the minute.

If you can take the time to study a building and see how light falls on it, you have the advantage of being in the best position to take your shot at the optimum time. At dawn or dusk the shadows are longer than at midday, and the contrast between light and shade is correspondingly greater. The light is also warmer at these times and can completely change the colour of a building's stonework. And with modern buildings you need to be aware of the sun reflecting off glass and steel back into the camera's lens, with potentially disastrous results.

Look for the different ways that light falls on a building. For instance, a small portion or detail can be highlighted by a single shaft of sunlight that makes it stand out dramatically.

Left: The problem with taking shots such as this is that the sun can come in from one side of the narrow passageway, leaving the opposite side in deep shadow. In this picture, the light is evenly distributed so that all the buildings are clearly visible, illustrating that even overcast days have their benefits.

Opposite: The light in this shot is warm and bright because it was shot in the late afternoon, in winter just before sunset. The curve of the London Eye makes a good contrast with the angularity of the building next to it. I'm always on the lookout for buildings and structures that I can juxtapose with one another.

Overleaf left: I had been photographing this house in the south of France and was attracted by the way the sun created patterns of light on different parts of the property. In this shot, the sun was shining through the trellis above the door, forming an attractive shadow on the wall. An hour later, the sun had moved and the wall looked quite flat by comparison.

Right and below: Often it is easy to think that you have a good shot of a particular scene, such as this one of an English village green. The view is pleasant enough, but on closer examination the shadow area in the foreground dominates the picture and is quite dull, as are the trees on the left. The sky is equally bland.

By comparison the dappled light in the foreground of the picture below adds interest to the shot, while the branch that frames the top of the picture hides the sky and helps to draw attention to the row of attractive cottages in the background.

Lighting Still Lifes

Still life photography is a great way to observe exactly what light does. Because you are building up your shot from scratch, you can see precisely how the light falls on each item that you use in the composition. Even in daylight, bad lighting is always reflected in the final result.

When setting up a still life, aim to give yourself as much flexibility as possible. For instance, if you set up on a table, you have the options of shooting from above, straight on or looking up. Having these options is important, as the camera viewpoint can dramatically affect the overall appearance of the final photograph. The same is true when it comes to setting up the lighting: being able to move your light source to the side, behind, below or above your subject gives a great degree of creative control. If you were to set up a still life on the floor or a shelf, you would be restricted in the movement of the camera and lighting, even if your final viewpoint was looking down.

Think about the lighting that can give the effect that you want to achieve. If you have only one light, consider the quality of that light – this does not mean the most expensive, but rather the type of light that is being delivered. Whether it's flash or tungsten, a reflector or dish determines the harshness and spread of the illumination. For example, a dish with a white surface delivers a light that is softer than one with a silver surface; a diffuser over the dish has a similar effect; a honeycomb fixed over the front of the light makes it more directional and crisp; a large softbox makes the light softer still; gels placed over the light create different colour effects; and barn doors help you flag unwanted light. Many of these attachments can be improvised from materials as simple as a piece of card and a bulldog clip. A spotlight enables you to project light onto a small area and focus it, and you can attach gobos to it that allow you to create patterns of light.

When shooting a still life in daylight, use reflectors to do the job that lights do. For example, a white card reflects a softer light than a mirror or silver foil. Where you position the reflector affects the length of shadow and the intensity of the light.

Lighting a black object

Black objects can be difficult to photograph and absorb enormous amounts of light. To shoot this spatula, I suspended it in front of black velvet, as this gives a far better black than paper. I used one flash head with a small reflector with a honeycomb fitted to it; this made the light more directional and therefore more controllable. Having got the light to my liking on the left-hand side (1), I then placed a mirror carefully underneath to give an edge to the bottom of the spatula (2). Once this was in place, I lit the right hand side using another mirror. I needed to take care not to overlight the object, because it would then have looked flat.

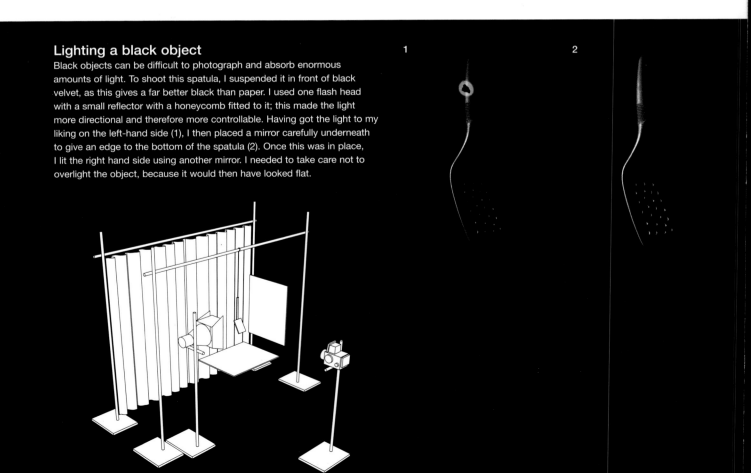

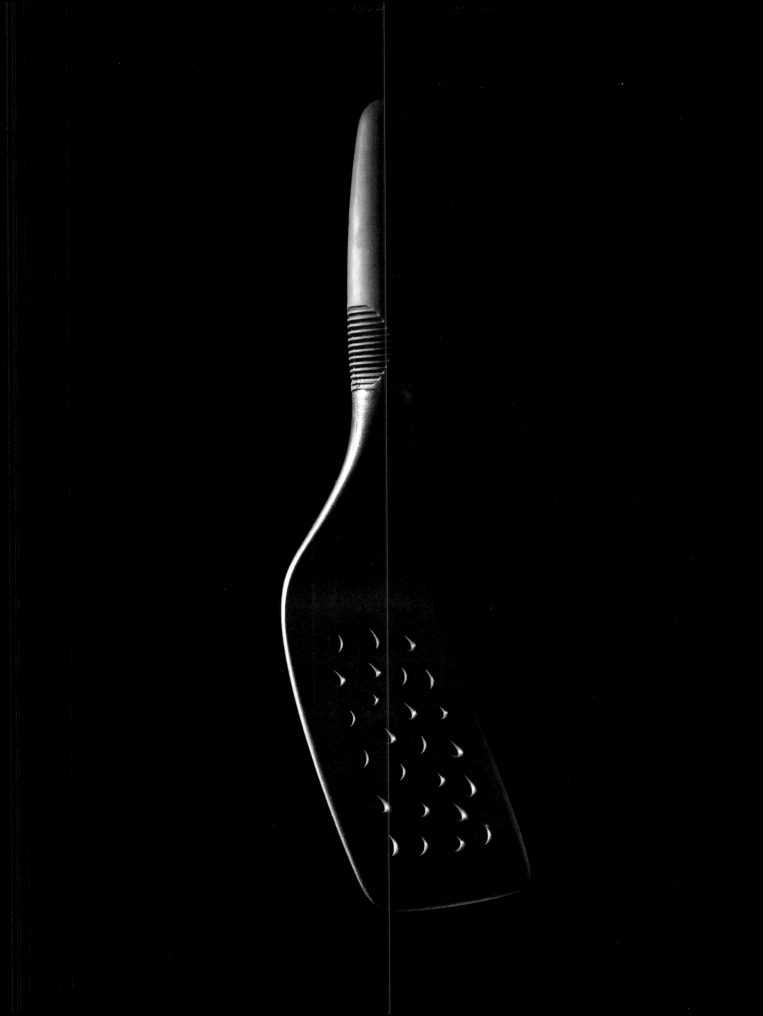

Above: This tapas dish was shot on a white background. One flash head fitted with a large diffused reflector mounted on a boom, was placed just above and behind the dish, pointing towards the camera. Using silver reflectors, I bounced light back onto the dish and used a 200mm lens fitted with a No. 1 extension tube to keep the area of sharp focus to a minimum.

Opposite: These glasses were placed on a white surface. I then fitted a single flash head with a large softbox, which I placed directly behind the glasses so that the light became the background. I next positioned black card on either side of the glasses to give them a crisp and clean edge. Both shots on these pages show how effective just one light can be.

3 Further Techniques

Basic Studio Light

Many photographers are daunted by the idea of shooting in a studio. However, a studio has one distinct advantage over shooting outdoors, and that is that you have complete control over the light – whether it is day or night, bright or overcast outside; these are considerations that you do not have to concern yourself with.

Studio lighting can be as simple or as complicated as you want it to be. Studio lights can be photofloods and spotlights or electronic flash. The former have the advantage that you can see exactly where the light is going and what it is doing. Electronic flashes have modelling lights, but these are only a guide to the final effect and not a completely truthful rendition. With electronic flash you can work at much faster speeds, the lights do not get hot in the same way as photofloods, and the range of accessories is vast.

Whatever your subject, you should always start with one light, known as the key light. By carefully studying the effect of the highlights and shadows this creates on your subject, you can begin to add more light. Note however, it may only be necessary to complement this key light with a reflector or reflectors (see pages 70–71).

When shooting a portrait, if you decide to add another light, make sure that this second light, known as the fill-in light, is of a lower power than the key light. Imagine that the shadow caused by the key light on your model's nose is replicated on the other side of their nose because both lights are of equal power - the result can only look very unflattering. The idea is to just lift the shadow area of the face. If you need to light the hair, use a boom, an arm that extends out from the stand with the light attached to one end and counterbalanced at the other so that it does not topple over, enabling you to light the top of your model's head without the light being in shot.

Each time you add or alter a light, check the camera's viewfinder; it is thus essential to have the camera mounted on a tripod or studio stand. The light looks quite different from this position than from where you are making adjustments.

Basic lighting for a portrait

1 Position the main, or key, light (a) to the right of the camera, pointing down towards the model's face. Look for the shadow to fall roughly between the nose and upper lip.

2 When you are happy with this, add another light to the side of the face (b); this is called the fill-in light, which is at a lower power than the first, key light – the same power would produce a double shadow on the nose.

3 If you like, you can now add a hair light, using a boom so that it is out of shot (c). Be careful not to use too much power with this light, as this can burn out the detail in the hair.

4 Place a reflector (d) under the model's chin to soften the shadows under the eyes and chin.

Opposite: To finish, direct two lights (e) towards the white background, adjusting them so they do not cause flare. The result is a well-lit portrait that includes the right amount of shadow detail.

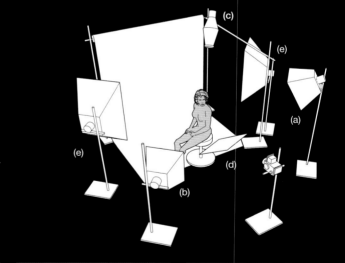

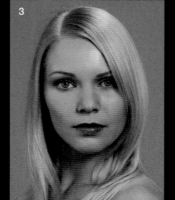

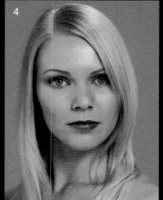

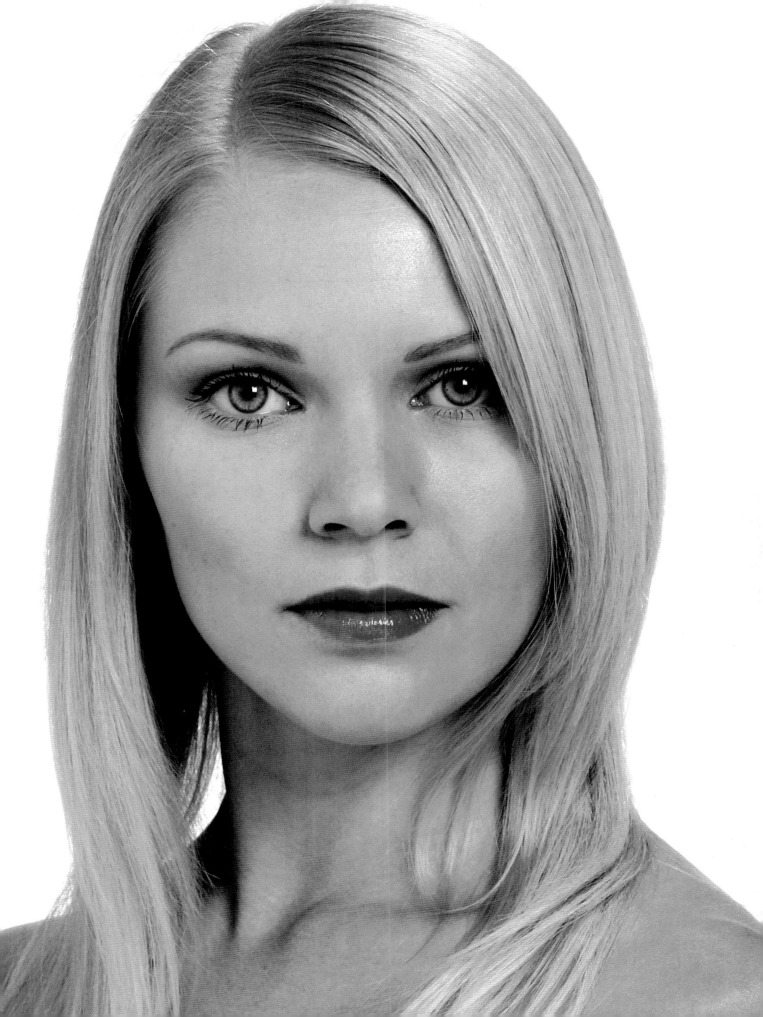

Further Studio Light

Once you have mastered the basics of studio lighting, you can start to experiment with different lighting set-ups. This does not mean that you have to buy more lighting, but that you can move your lights into different positions to obtain different effects.

Start with one light, placing it in different positions so that you can begin to see the endless possibilities that are available to you; this is the case when photographing both a person or a still life.

Another way in which you can change the quality of the light is to place a honeycomb over the light's reflector. As its name suggests, a honeycomb is a metal grid with lots of tiny holes in it that make the light more concentrated and directional, and help to reduce "spill", which is when the light flares around the edges. Honeycombs come in different grid patterns, and only by experimenting with them can you find the one best suited to the shot that you have in mind.

In addition to fitting this type of grid, you can also fit barn doors onto a light. Barn doors have four moveable flaps that can be angled to control the light that spills onto an area of the shot that you do not want to light; when the light is shielded in this way, it is known as flagging. You don't have to use specialist equipment for this – you can just as easily use a piece of black card or other non-reflective material.

If you have a focusing spotlight, you can use an extensive range of gobos, small metal discs that have various patterns cut in them. Some gobos can be quite random in pattern, while others are designed to recreate the glazing bars of a window, a tree or the flames of a fire.

Spotlights have a focusing lens at the front of the lamp in much the same way as a slide projector does. The gobo fits between the lens and the light source, and the pattern is then projected onto the surface or person and can be softened or sharpened by focusing the lens.

Opposite: I created this shot in the studio using two lights and some reflectors. The main light was a focusing spotlight, which I positioned above and to the right of the planter. I created a shadow on the wall that looked as though it was the sun shining down, and placed a gobo in the spotlight so that the light, when it fell on the planter and wall, would be very slightly dappled. I then placed another light next to the spot **light but fitted it with a softbox; this was far less directional and softened the effect of the spotlight without killing it. I next placed a large reflector to the right of the scene but out of camera. Other smaller reflectors were placed at ground level to throw light back onto the watering can and other objects. The final result is a studio shot that looks as though it has been taken outdoors.**

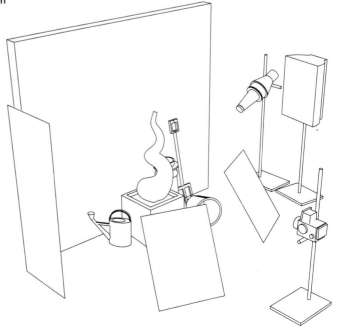

Above: This large mirror was placed against a wall, and a length of muslin was hung to the left to look like curtains. I placed one studio flash behind the muslin and shone it towards the mirror. On the opposite side I placed a large reflector, which created a soft daylight look. I decided to have something reflected in the mirror to make it look more convincing. I shone a spotlight fitted with a window gobo on the opposite wall so that you could see it reflected in the mirror.

Above: For this full-length portrait I used a single flash head fitted with a beauty dish, placed to the left and slightly above the model to create a harsh light that fell at right angles to the camera viewpoint. I angled a full-length mirror to the right of the model to bounce light back onto her. This has created a crisper light than if I had used a white reflector. I then fitted a spotlight with a gobo to create a random light pattern on the wall behind her. I then focused the spotlight to soften the effect of the gobo.

Above: I placed this model against a black velvet background and then directed two lights towards the camera, at equal distance, behind her. These gave an attractive highlight on either side of her hair. I then placed two large white reflectors either side of the camera and directed the light back into her face. I used a 150mm lens on my Canon 1DS camera for the shot.

Above: I photographed these flowers on a light table made of opaque perspex and curved to create a seamless light effect. I placed one studio flash beneath the table and pointed it up to the perspex. I then placed another at the back and also pointed that towards the perspex. This made the flowers look as though they were floating in space. I directed another flash head fitted with a softbox down onto the flowers so that they were not in silhouette.

Backlighting

Some people believe that the correct way to light a photograph is to have the sun or other light source coming from over your right shoulder so that it falls directly onto your subject. However, stunning shots can be obtained by shooting directly into the light. Of course a certain amount of care needs to be taken, and a lens hood or improvised shield is essential to prevent flare. Accurate exposure meter readings are also required.

When taking the exposure meter reading for a backlit picture, it is essential to read the light falling on your subject, not the light coming from behind. There are several ways of doing this. In the first, if you are using a hand-held meter, you can take your reading by the incident light method, in which a white opaque cover is placed over the light-sensitive cell. Instead of pointing the meter towards the subject, as with other metering systems, you hold the meter in front of the subject and point it towards the camera. The meter then reads the light falling on your subject, not the light reflected from it. This type of reading is the most accurate you can get, and is not just restricted to backlit pictures.

Another technique is the spot meter method. Some cameras have this facility built in, or you can use a separate meter. As the name implies, this method measures a small area of your frame, perhaps up to 3 per cent. When taking a backlit portrait, you can have this part of the meter centred on your subject's face and take your reading from this small area. Remember that if you are using a reflector to bounce light back into your subject's face, you need to take your reading – whatever the method – with the reflector in position, otherwise your shot will come out overexposed.

Backlighting is particularly effective if you want to pick up smoke or steam; if you try to shoot these with the light coming from the front, the smoke and steam are likely to burn out and thus become virtually invisible. Another aspect of backlighting is the halo of light that can be produced around a person's head, filtered through their hair.

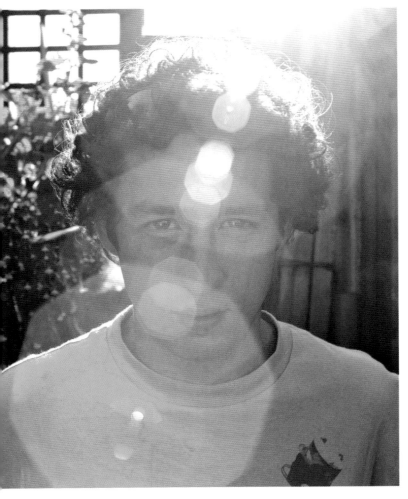

Left: When shooting into the sun, you need to position yourself so that direct light does not enter the lens and cause flare, as shown here. The most obvious remedy is to use a lens hood, but even with one fitted it may still be possible for the light to stray into the lens and ruin your shot.

Opposite top left: This shot of a basket of flowers was taken with the sun directly behind the basket. I used a 200mm telephoto lens and a No 1 extension tube, which enabled me to get in really close and have the focus on the flowers in front.

Opposite top right: I noticed this woman sweeping and was attracted by the sun filtering through her hat; it almost looked as if she was wearing a halo. I positioned her with her back to the sun and took my exposure reading from her face.

Opposite bottom: This fisherman was gathering his nets early in the morning. The light was still quite low and came from behind him, playing on the water and highlighting the net. After I had taken the shot, I observed him with the light in a different position. The net was dull by comparison and blended into the water.

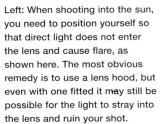

Overleaf right: At a temple in China. When I looked at these incense sticks with the sun behind me, none of the smoke could be seen; as soon as I looked at them with the light in front of me, all the smoke was visible. I chose a 200mm telephoto lens together with a 2X converter, and positioned the camera at a low angle so that I looked up to the smouldering incense sticks.

Overleaf left: Shots such as this need careful exposure because there is always the chance that with backlighting the person, together with the arch she is walking through, can come out as a silhouette. I took one reading from the grass that was bathed in sunlight as it came through the arch and another for the grass next to it, which was in shade. I then took the shot, averaging the two exposure meter readings.

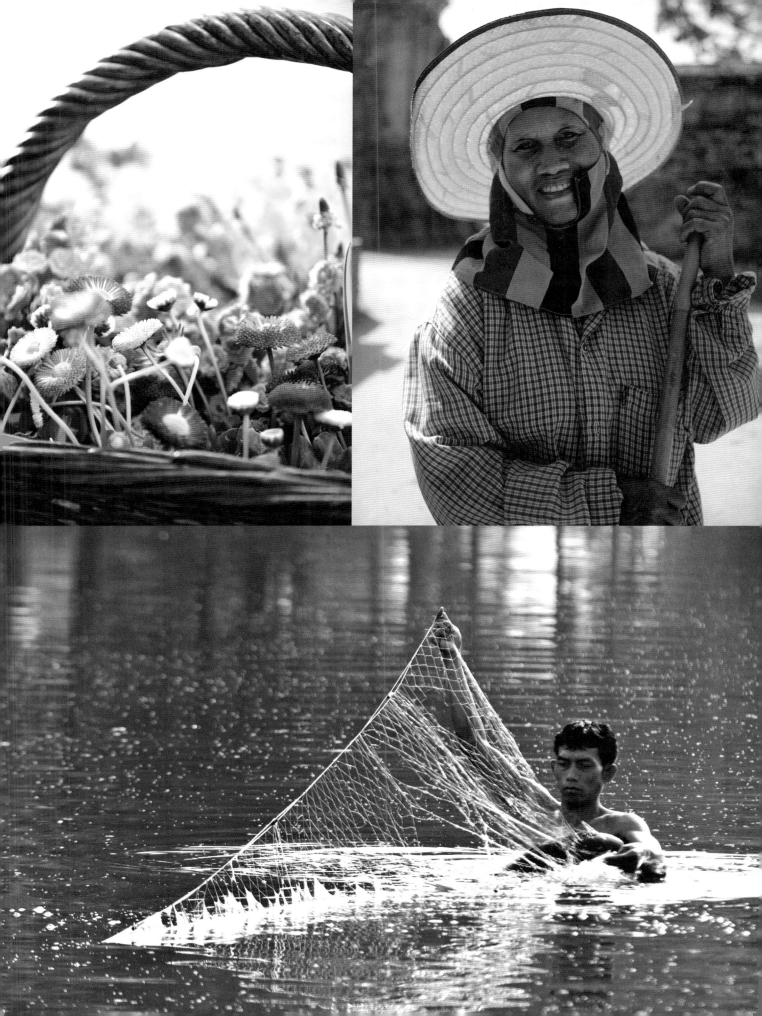

Ring Flash

Ring flash, as its name suggests, is a 360° circular flash tube that fits around the lens on which it is mounted, and synchronizes with the camera in the same way as conventional flash units. There are many different models, ranging from small, portable battery-powered units that are best suited to 35mm cameras and lenses, through to much larger, more cumbersome ones powered by studio flash units, which are more appropriate for use with medium-format cameras. Ring flash can also be used in conjunction with other flash units, either as the main light source or as a fill-in light. When shooting outdoors, ring flash can be used for fill-in flash.

The original use of ring flash was for medical and forensic photography, as you can get very close to your subject using extension tubes or bellows, while still having a light source that provides completely even illumination. However, ring flash soon became popular with commercial photographers, particularly fashion and wildlife photographers.

Ring flash gives an almost shadowless light and very even illumination. If your subject is against a wall, for instance, there is a soft, halo-like shadow all around them. In colour photography red eye can sometimes be a problem with ring flash, but this can easily be removed, either on the computer or retouched by hand later. Because of this shadowless lighting, ring flash is also great for intricate subjects that have a lot of detail, such as the constituent parts of a car engine or the circuit board of a computer. When using conventional flash in a situation of this kind, the light comes from one side or above the lens, and it is easy to create shadows to one side of the subject, as it may not be possible to use a fill-in light or a reflector in such a restricted space; using ring flash solves the problem quickly.

As with all equipment, using ring flash requires a degree of experimentation before you really start to see how original this type of lighting can be. This is relatively easy if you are using a digital SLR, as the results are instantly viewable on the LCD.

Left: I chose ring flash as the light source for this portrait. It produced a striking, shadowless light that gives the shot a more gutsy appearance than if it had been taken with conventional flash and a softbox.

Below: This is how a ring flash attaches to the lens of a camera. This illustrates a simple battery-operated model; others work off studio flash packs and are much larger in construction.

Opposite: Many subjects lend themselves to being shot with ring flash. I used textured paper for the background and broke the bloom from the stork so that the flower would lie flat. I used a 70mm lens and took the shot with the camera about 50cm away from the flower.

Above: Ring flash is great for intricate mechanical objects, such as car engines or clocks. In these two shots you can clearly see the difference between flash attached to the camera's hot shoe (right) and ring flash (left). The ring flash has produced shadowless lighting, while the conventional flash has created shadows, some of which cover important detail.

Opposite: I positioned the model against a wall and then took the shot using ring flash. In addition to giving a shadowless light, you can detect an even shadow all around her on the wall. This effect is typical of ring flash and is part of its attraction.

Using Fill-in Flash

The difference between using fill-in flash and reflectors is that with reflectors you can see the effect that they have immediately, whereas with fill-in flash you have to wait until you have taken your shot and then review it on the camera's LCD, or wait until the film is processed.

So why use flash on a well-lit, sunny day? The main reason is that bright sun can cause unattractive shadows in the eyes and under the chin. By using a small amount of fill-in flash, these shadows can be eliminated or softened.

Another situation for using fill-in flash is when the person you are photographing is in shadow but the background is in bright sun, and you want to retain the detail of the background. If you expose for the background, the person is underexposed and comes out as a silhouette. However, if you expose for the person, the background is overexposed and all the detail is burnt out. Fill-in flash evens out the exposure needed.

The secret to working with fill-in flash is to use the flash at a slightly different setting to the one that the manufacturers advise – even dedicated flashguns that calculate the amount of flash required for any given shot may need to be overridden. The reason for this is that they balance the flash perfectly to the daylight, which gives the shot an obvious flash feel.

To calculate how much fill-in flash is required, imagine that the daylight reading is 1/60th second at f11, but the subject has dark shadows under the eyes and nose. The camera is set to this exposure, but you need to set the flash to give half (1:2 ratio) this exposure, or even a quarter (1:4 ratio). This means that the flash is set to give an exposure of f8 or f5.6 – in other words, less flash output than the daylight. The shot is then taken at f11; at this combination the background is perfectly exposed and the amount of flash falling on your subject is just enough to soften these shadows and make for a more flattering portrait.

If a camera with built-in flash cannot do this, you have to rely on the camera's fill-in flash mode, if it has one. Because daylight continually changes, it is impossible to say exactly what the combination should be; only practice makes perfect.

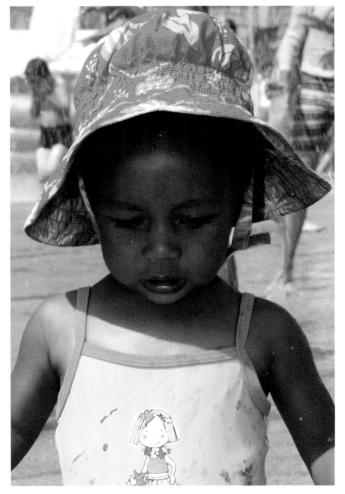

Left and opposite: Even in bright sun, exposure and lighting can be problematic. In the shot on the left the child's face is in shadow caused by the brim of the hat she is wearing. However, by using fill-in flash (opposite), the child's face has been brought to life and the overall exposure is much better. This shot was taken with a dedicated flash unit with the camera set to fully automatic.

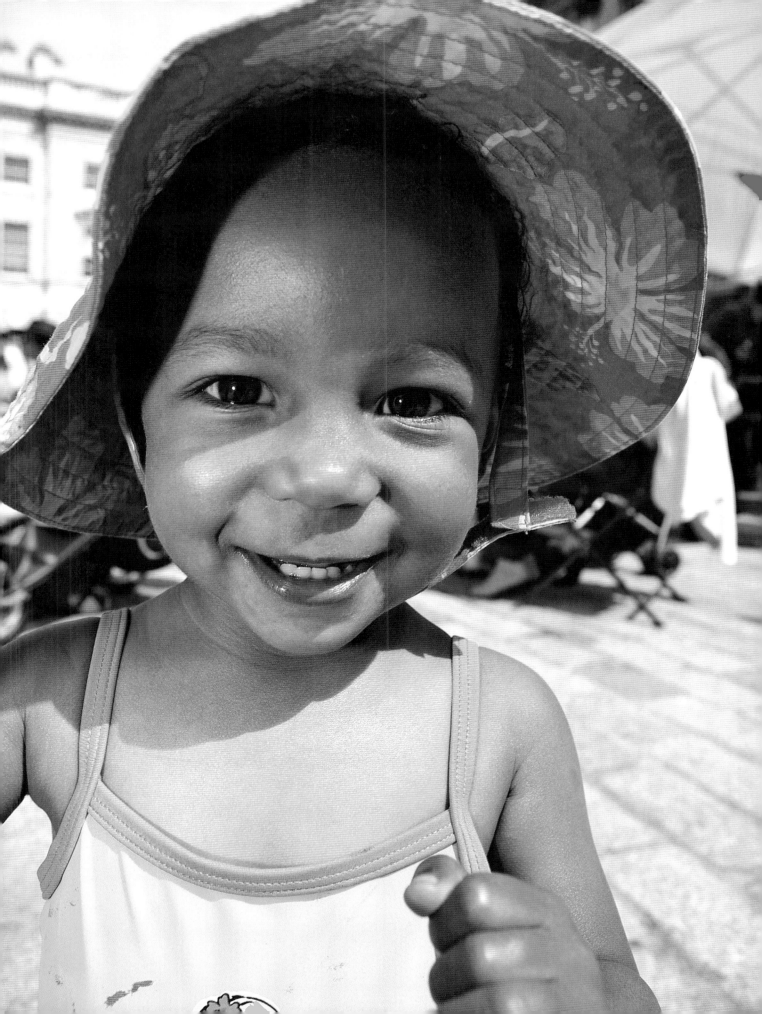

Left: You can tell by the direction of the model's shadow that the light is behind her and that she is underexposed.

Above: A small amount of fill-in flash is all that was required to lift the level of illumination on her. Far from being obscured, she now stands out, and all her facial features can be clearly seen.

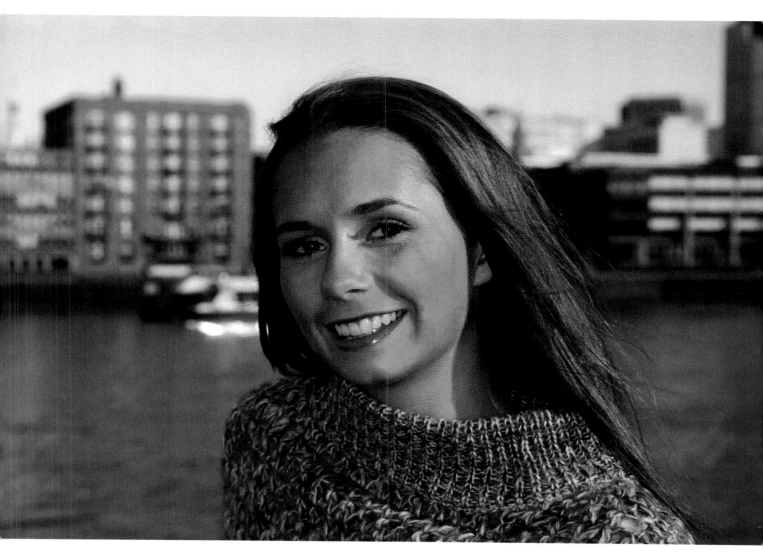

Right: Sunlight can play real
havoc when taking outdoor
portraits, causing heavy shadows
in the eye sockets and other
areas of the face.

Above: Fill-in flash can correct
shadows, but it is important that
the background is kept evenly
exposed, otherwise your shot can
take on a night time appearance.

Night Light

A surprising number of people think that it is only possible to take successful pictures in daylight – and if they do take them at night, they always use flash to supplement what light there is.

However, there are just as many opportunities at night for getting good pictures where flash or other additional light sources are not necessary: in cities all over the world large buildings are lit up, for example, and there are neon signs and street lighting all around. There are also quite a few events that take place at night, such as firework displays, that give you the opportunity to take great shots.

The essential piece of equipment for night photography is a tripod, preferably used in conjunction with a cable release. Most night shots are taken at very slow speeds, in some cases several seconds, and it is impossible to hold the camera steady for this length of time. Of course you can set the ISO on your camera to a higher number or use a faster film, but this is likely to be at the expense of quality, as the noise or grain increases, making quality enlargements more problematic.

Many shots taken at night look better in what is known as the twilight period, the time between sunset and complete darkness where the sky takes on a deep blue hue. (Completely black skies can look very boring in a photograph, especially if they take up most of the frame.) However, this twilight period tends to last for only about 20 minutes at a maximum, so you have to be quick to take advantage of the light; it pays to be in position and to be completely ready a while before you actually need to shoot.

If you are photographing a firework display (see overleaf) study the sky so that you know where the fireworks will explode. With the camera set to 100 ISO (or using a film of the same rating) choose the B setting on the shutter speed dial. This stands for 'Bulb' and when the shutter is fired it will stay open for as long as the shutter release is depressed.

Above: Many buildings are illuminated at night and provide good photographic possibilities. Some have changing light displays, such as the Hong Kong and Shanghai Bank building in Hong Kong. I took a series of pictures over a short period of time so that I could record the varied colours, and mounted them together in a series.

Opposite: In this shot, also taken in Hong Kong, the neon signs that hang above the street dominate the picture. Together with the traffic that fills the remainder of the frame, the shot exudes the vibrant and busy atmosphere that is synonymous with this city.

Above: Fireworks make great pictures, but it is easy to get them wrong. By using the B setting on the shutter you can keep the shutter open for just the right amount of time, enabling you to get the correct exposure.

Left: in this shot the shutter was left open for too long, and the detail of the fireworks was burned out.

Above: When photographing street lighting displays, such as these Christmas ones, it is essential to use a tripod. It will be impossible to hold the camera steady at slow shutter speeds, and certainly for 10 seconds, which was the exposure set here.

Left: You can see the effect when a tripod is not used.

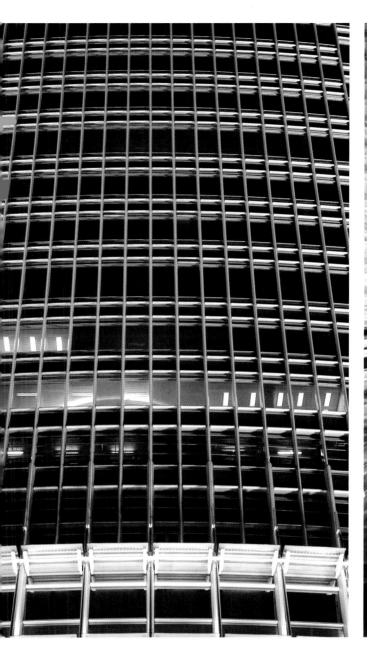
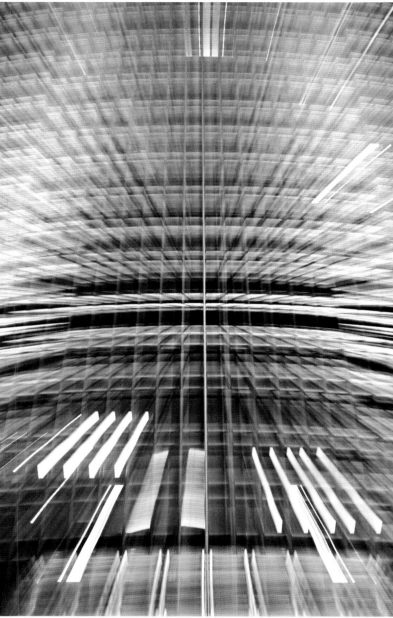

Above: The building on the left had a façade that was quite bland, as some modern buildings can be. To give it some life I placed the camera on a tripod and chose a shutter speed of 2 seconds. As soon as the shutter had been released, I gradually and smoothly altered the focal length of the zoom lens as the shot was being taken.

The result on the right is far more interesting, and the highlights of the interior lights add to the picture's abstraction.

Using Reflectors

Particularly when shooting portraits, you may find it necessary to have your subject with their back to the sun, because if they face the sun they may have to squint or screw up their eyes. The result however can be that the light then falling on their face is not very flattering. On the other hand, perhaps they are wearing a hat, which causes a shadow to fall across their face.

Even when you are shooting a still-life setup, part of your picture may be in shadow, or the shadow is too strong, making the overall picture contain too much contrast. You can overcome these problems by using a reflector to bounce light back onto the subject – and the great thing is that you can see exactly the effect the reflector is having before you take your shot.

A reflector is any piece of material or surface that can be used to reflect light onto or at the subject of your photograph. Purpose-made photographic reflectors, available from photographic dealers, come in a variety of shapes and sizes. When not in use, they can be folded up into a manageable size

and carried in a small pouch. Some larger reflectors come with an expanding frame over which the reflective material fits. This reflective material may be single-sided in white or silver, or double-sided, usually with gold or silver on one side and white on the other. When using a large reflector, you need either a stand to support it or an assistant to hold it.

Of course, it is not necessary to buy a purpose-made reflector, and you can improvise quite easily by using any object with a light surface, such as paper or fabric; when taking a tightly cropped head shot, even the light bouncing off a newspaper or the pages of a book can act as a fill-in. These tricks are useful if you find yourself having to take a shot without a proper reflector to hand.

Whatever type of reflector you use, it is important to remember that when shooting a portrait, even the reflected light can be so strong that it has the same effect on your subject's eyes as direct sunlight and they start to squint, which, is what you started trying to correct.

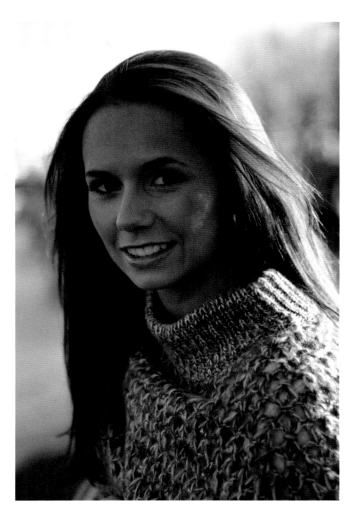

Far left: I took this shot with the sun behind the model's head. It's pleasing enough but looked on the cool side, and I decided it would be better if I reflected some light back into her face.

Left: I chose a silver reflector and got the model to hold it. This has added more light and the shot now looks a lot more attractive.

Opposite: I then tried the gold side of the reflector and decided that this gave the result that I wanted. It has made all the difference to the sparkle in her eyes, and has taken the cold appearance away.

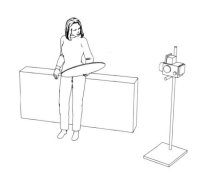

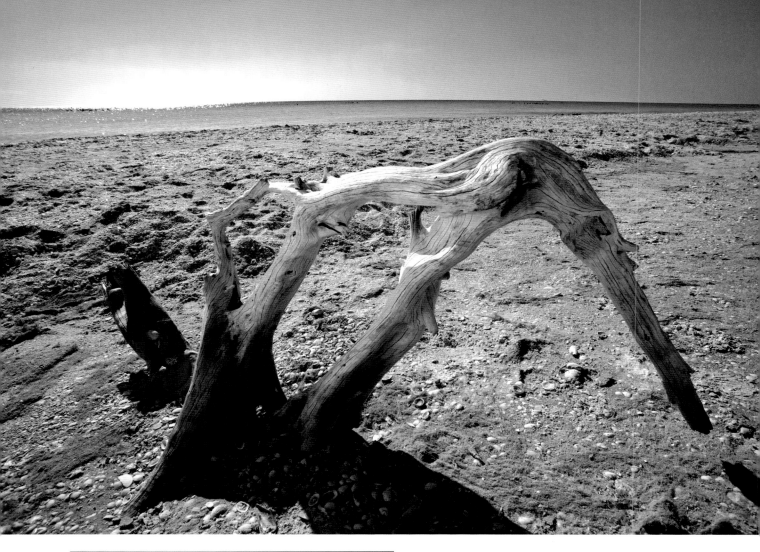

Above and top: In addition to using reflectors for portraiture, they can be used for many other subjects. In the shot above, the old weathered piece of wood looked quite dull, but by reflecting light back onto it, at top, with a gold reflector gave it a lift and made it stand out more prominently from the background.

Opposite: This shot was taken by available light that was coming in from the pleated blind that doubled up as the background. I used two large white reflectors either side of the girl to reflect light back onto her. The result is an even, softly lit portrait.

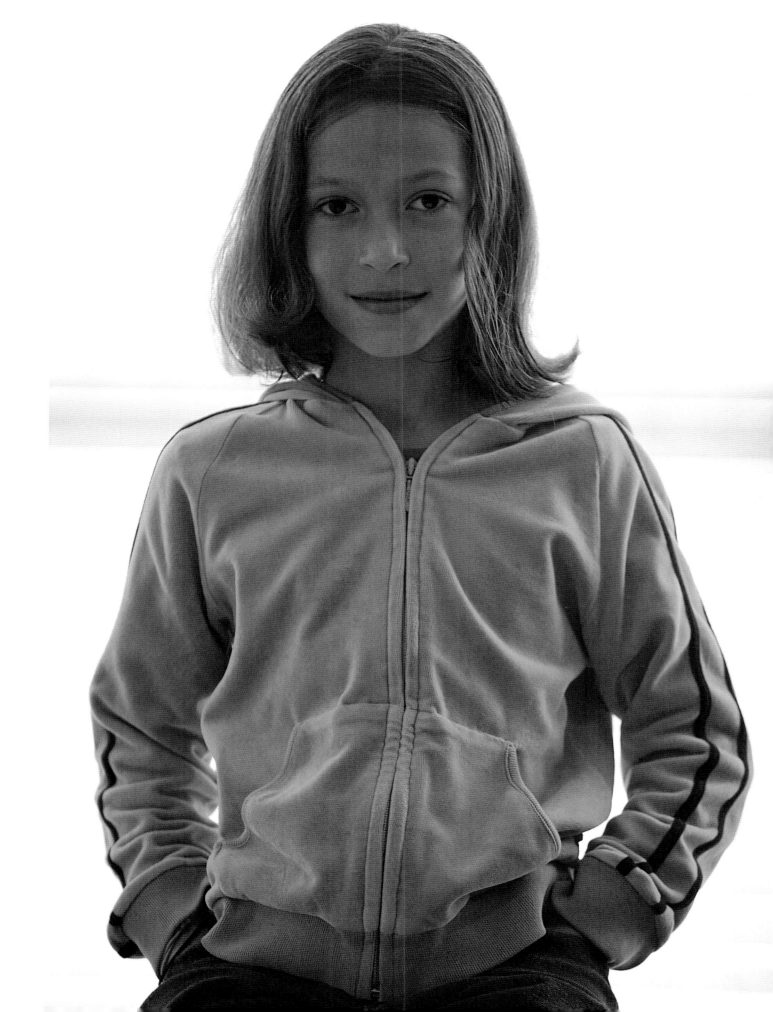

Alternative Lighting

In addition to daylight, flash and tungsten, there are many other types of light that can be used to take effective and in some cases unusual pictures. In fact, so long as light is emitted from any source, it is possible to take a picture.

As an example of what can be employed, there is no reason why, with a little improvisation, the headlights of a car or motorcycle can't be used to light a subject in a dramatic and unusual way; depending on the positioning of your subject and the light source, strong shadows can enhance the overall composition of your shot.

A torch is another alternative light source. The great thing about torches is that they can be held by your subject close to their face to get ghostly lighting effects. Or you can use several torches, perhaps with coloured gels, each one directed at a different angle. With your subject seated, you can see exactly where the light is going and the effect it is having.

Candles or matches are yet another source of alternative lighting. With the former, you can build up the amount of light with as many candles as you think necessary; the candles can be arranged around your subject until the required level of illumination has been achieved, together with the desired effect. Just be careful not to set something on fire or burn your model!

The one thing that all these alternative lighting sources have in common is that they are low in power so a long shutter speed is therefore necessary. Because of this a tripod and cable release are essential, and a higher ISO setting or faster film may also be necessary – it can be just as difficult for a person to stay still as it will be to keep the camera steady without a tripod.

If you set the white balance on your digital camera to auto, some of the lighting effect can be lost, as the camera may try to neutralize the warmth that this type of lighting gives. It is far better to experiment with the Kelvin (K) setting until you have achieved the balance you feel is right. Once you have taken your shots and downloaded them onto your computer, you can make further adjustments – often tiny ones – to enhance the overall feel of the picture.

Above: I shot this girl using just the light coming from the candles that were positioned around her. The exposure was 1/2 second, which meant that she had to keep perfectly still when the shot was being taken, otherwise she would have come out blurred.

Above: Although this candle set into an artichoke was surrounded by other light, it still needed a slow shutter to record the flame. Working with this level of luminosity means that a tripod and cable release are essential if the subject is to remain sharp.

Opposite: This shot was taken with just the light coming from the cigarette lighter. I particularly liked the way it illuminated the fingers of the left hand, making them glow. The model managed to hold still long enough for me to take the shot using a shutter speed of 1 second.

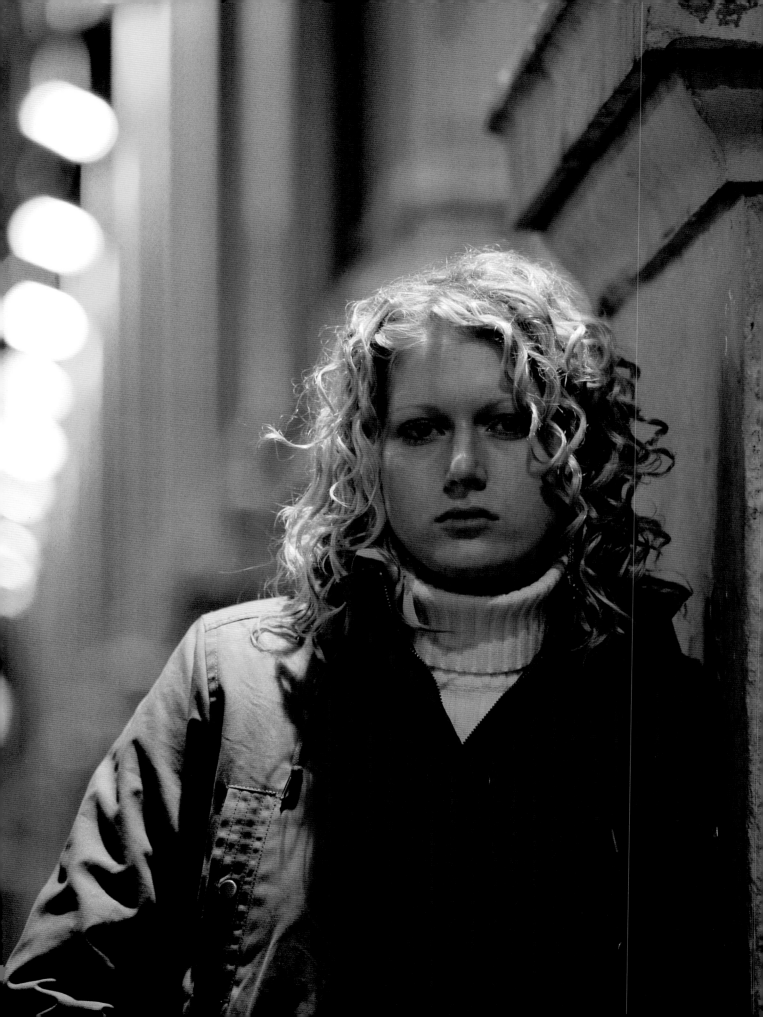

Opposite: Street lighting can be great for moody portraits, such as this one. I deliberately chose a low viewpoint so that I could get the lights in the shot, and used a 200mm telephoto lens set on f2.8 so that the background would go out of focus.

Above: Club lighting can be difficult to judge: it is constantly changing, making an accurate light reading virtually impossible. For this shot I set the camera's metering mode to fully automatic. This gave a fair reading in the circumstances, and looks far better than if I had used flash.

Stroboscopic Lighting

Most people associate stroboscopic lighting with clubs and dancing, but in photographic terms it is a form of lighting that has been in use for a very long time. When taking pictures with stroboscopic flash, a rapid series of flashes is fired, producing a succession of pictures of a moving subject that are recorded in a single image.

Stroboscopic pictures also have scientific applications. For instance, by recording the progression of a moving subject, scientists can study minute movements in the way the limbs of a body move while walking, jumping or running, or the movements of a bird in flight – in fact the path of any moving object, living or inanimate, can be recorded with stroboscopic flash.

Many small dedicated flash units have the capability to fire a burst of stroboscopic flashes. The problem here is that these flash units can easily overheat when firing in this mode and cause the flash head to deteriorate at a faster rate than if the unit is being fired in a more conventional manner. In between firing a burst of flashes, you need to let the unit cool down, which can slow you up. Nevertheless, don't let these shortcomings stop you attempting this type of photography.

The best equipment to use for stroboscopic photography is an electronic flash power pack. With these packs you can programme an infinite amount of flashes, control the time for each flash to fire and even vary the speed of the flash itself. The packs are also unlikely to overheat.

What is important is that you must choose a shutter speed that can accommodate the full number of the programmed flashes. For instance, if you have programmed a series of 20 flashes to fire every 1/10th second, you need the following formula: $20 \div 10 = 2$, meaning that you need a shutter speed of at least 2 seconds to give the camera enough time to record all the flashes. Because the majority of stroboscopic pictures are taken against a black background with all other lighting switched off, you can set the shutter to B and start the flash sequence manually. Stroboscopic pictures work best when the subject moves across the frame, rather than remaining fixed.

Opposite: Stroboscopic lighting works best when the subject is moving across the frame, rather than moving in a fixed position. In the shot at far left, the strobe fired five times and the result is rather messy. Even with only two flashes, on the left, the results aren't great and the girl's body looks as if it has been shaken.

Above: In contrast, when the model moves across the frame the result is far more clearly defined. In this case the girl moved slowly from left to right and the stroboscopic flash fired three times.

Right and overleaf: When I took these shots of a gymnast the difficulty was capturing her full routine. Either I started the sequence too early, so that the last flash fired before she had finished (above), or I started too late so that she ended up out of the frame (below). In the end I shot her exactly how I wanted her, in the various stages of her routine, that pleased her and her coach (overleaf).

Digital Enhancement

No matter how careful you may be in taking your shots, errors are bound to occur from time to time. For instance, perhaps the landscape picture you took has an overexposed sky because you didn't use a graduated neutral density filter to balance the differences in light between the foreground and the sky

In a portrait shadows which have gone so dark that they look murky and unattractive, may have been caused by not reflecting a certain amount of light back into the shadows or by using a certain amount of fill-in light. In other situations it could be the case that the contrast is so low the picture looks washed out, or that the shot has a colour cast and the subject you photographed now looks unnatural.

When shooting on film, if you know that you have under- or overexposed your shots, you can make adjustments in the processing or at a later stage when making the print. However, there is a limit to what can be done to retrieve the situation, and once the film has been processed the results are fairly final. The other point to bear in mind is that if you push or pull film (adjust the development times either up or down), you alter the colour balance. For example, when you push film it tends to become more magenta, whereas pulling it tends to produce more cyan. Contrast is also increased when film is processed this way.

Digital cameras give photographers an image to evaluate and an indication of any adjustments that need to be made. This takes just seconds, making it more likely you can optimize the shot in terms of either lighting adjustments or exposure.

If a less than perfect shot does get through the net, there are a variety of digital enhancements available to you on your computer. For example, you can use Curves to adjust contrast as well as brightness, and the Hue/Saturation tool for colour balance. As most images that are to be printed usually benefit from a degree of sharpening, another useful tool is the Unsharp Mask in Photoshop, which gives an illusion of sharpness by exaggerating the differences between the light and dark parts of the image.

Improving the light

Even if your shots are not as you intended, you can still produce a good image once you have downloaded it into the computer. In this case, the foreground is far too dark, but if I had exposed for this, the background would have been overexposed.

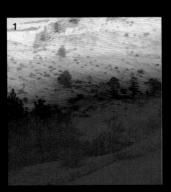 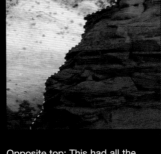

Opposite top: This had all the potential to be an attractive landscape picture, but the foreground was far too underexposed. If I had given it more exposure, the background would have been overexposed and burnt out.

1. In the valley I made a selection with a soft edge for the foreground, and saved it.

2. For the rocky outcrop on the right I used the Lasso tool to precisely select it. I then joined both these selections together.

3. Having joined the selections together, I used the Brightness, Contrast and the Curves command to brighten the shadow area. Because the shadow area was quite cool and bluer, I added warmth with hue saturation.

4. Because the image still looked a little on the cool side, I used the photo filter effect in Photoshop CS to replicate an 81A warm-up filter. Opposite bottom: The result is a much improved version of the original image.

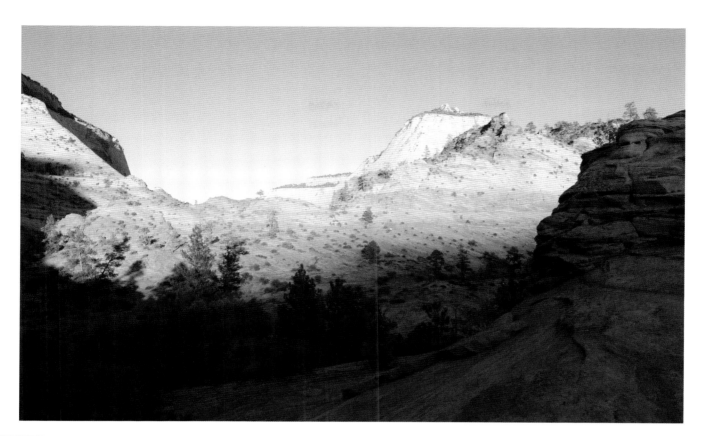

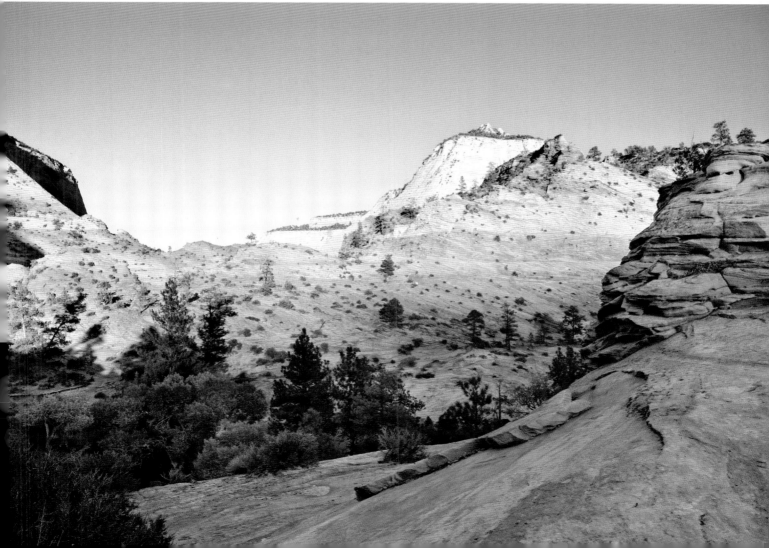

Digital lighting enhancement

Photoshop offers the photographer a variety of different effects that enable you to improve or correct the lighting in an existing image. One of these can be found in "Filter" on the menu bar at the top of the screen, and is called "Lighting effects" (below). Using this, you can create many different lighting effects:

1. Original image
2. Torch
3. Directional light coming from the right-hand side.

Opposite: The finished shot, showing an uplit effect .

High Key

High-key pictures are ones in which the tonal range of the print is primarily at the light end of the scale. High-key pictures are not to be confused with high-contrast prints, which have extremes of tones, with very little in the mid-tone range. Low-contrast prints have a narrow range of tones, with no definite black or pure white. However, this result is often due to underexposure, rather than a deliberate technique.

A photograph is usually judged not only on its subject and composition, but also on its tonal range throughout the scale; in black-and-white photography this includes rich blacks, clean whites and a range of grey tones in between. However, this doesn't always produce striking photographs, and from time to time it pays to bend the rules.

Softness and delicacy are the essence of high-key pictures, and a soft light is nearly always necessary to achieve them. The easiest way to obtain this type of light is to use a softbox; this fits onto the flash head and, as its name implies, is a large pyramid-like box, black on the outside and lined on the inside with a reflective material, usually white or silver. The white-lined variety gives a softer light than the silver, so it is well suited to the type of shot you are trying to achieve.

Inside the softbox there may be a baffle in addition to the outer diffusing material that the light passes through. The more the light is filtered through this material, the softer that light is, so once you have the light in position you may decide to add more material between the light and the subject. Muslin is a good choice for this, as it is very effective in diffusing the light and is relatively inexpensive.

Another way to create a high-key light is to bounce the flash off white surfaces, such as polystyrene boards, which in turn can be diffused with muslin. It is probably best to slightly overlight the background to emphasize the high-key look. However, you do not want to create flare, so the exposure required for this needs to be carefully calculated. This type of lighting is applicable to both portraits and still lifes.

Left, above left and above: I shot this young girl in a studio against a white background and deliberately kept the light soft and bright. This had the effect of making her stunning blue eyes stand out from the fairness of her skin and naturally blonde hair.

Opposite: I photographed this girl against an illuminated advertising hoarding that was entirely backlit. I took my exposure meter reading for her face, which meant that the background went very light and caused a certain amount of flare. I thought this effect was very attractive, and the result is a very high-key portrait.

Opposite: I placed these orchids against a white background and lit them from above using a studio flash with a softbox positioned just above the flowers. I placed white card to the sides and underneath creating a light box effect. This made the light very soft and the picture very high-key.

Left: Having positioned this girl in a floor-to-ceiling bay window, I shot her using only the daylight coming in from it. This gave a very soft, even and romantic light that goes well with the flimsy dress that she is wearing.

Low Key

Where high-key pictures are those where the tonal range of the print is primarily at the light end of the scale, low-key pictures are those where the tonal range of the print is at the dark end of the scale. Pictures produced in this manner can have a great cinematic or theatrical feel, and look very dramatic.

When planning to shoot this type of photograph, the first thing to consider is the background. Most photographers usually use black velvet, which gives a much richer black than standard photographic black background paper because the paper is slightly reflective, while the velvet absorbs light.

When calculating your exposure for low-key lighting, take the reading from the highlight area of the shot; if you take a reading that is in deep shadow, your shot is likely to come out overexposed. Remember that problems can sometimes occur in deep shadow areas, so be prepared to spend some time adjusting and setting up your printer for the optimum results when it comes to producing digital prints. This might also mean trying a range of different papers in addition to the ones supplied by the printer manufacturer.

Try to use directional lighting rather than softboxes, which, as the name implies, create a soft light. This may mean fitting a honeycomb grid over the light. Honeycombs come in a range of different meshes, from coarse to fine, each of which has a subtle effect on the quality of the light, so you need to experiment to find the one that suits the style and the effect you are trying to achieve.

Once the honeycomb is fitted there is very little spill, but you may still find it useful to fit barn doors to the light so you can flag the light and stop any going where you don't want it to go.

You may find that one light is all you need and that the rest can be done with a variety of reflectors, which can be used to put a certain amount of light into the shadows.

However, for deep shadows try placing a piece of black card or a black board next to your subject to absorb any stray light and stop it being reflected back onto your subject.

Low key

Left, opposite and overleaf: These shots were all lit using just one light and a combination of reflectors and flags. Getting the exposure right can be tricky with low-key lighting, as there is always the danger of overexposing the shot if you take your reading from the area of deepest shadow. On the other hand, if you do underexpose, the shadow areas may become difficult to print; and if you are shooting digitally; they can suffer from excessive noise.

Another problem with low-key photography is focusing. In low light conditions, many auto focus cameras have difficulty in focusing, as there is little definition that the focusing sensor can home in on. I find it best to get the subject in focus and then switch the auto focus mode off. Unless your subjects are moving about erratically, they should keep within the area of sharp focus.

Glossary

Alpha Channel
Extra 8 bit greyscale channel in an image, used for creating masks to isolate part of the image.

Analogue
Continuously variable.

Aperture
A variable opening in the lens determining how much light can pass through the lens on to the film.

Aperture Priority
A camera metering mode that allows you to select the aperture, while the camera automatically selects the shutter speed.

Apo Lens
Apochromatic. Reduces flare and gives greater accuracy in colour rendition.

APS
Advanced Photo System.

ASA
American Standards Association; a series of numbers that denotes the speed of the film. Now superseded by the ISO number, which is identical.

Anti-aliasing
Smoothing the edges of selection or paint tools in digital imaging applications.

Auto-focus
Lenses that focus on the chosen subject automatically.

B Setting
Setting on the camera's shutter speed dial that will allow the shutter to remain open for as long as the shutter release is depressed.

Back Light
Light that is behind your subject and falling on to the front of the camera.

Barn Doors
Moveable pieces of metal that can be attached to the front of a studio light to flag unwanted light.

Between The Lens Shutter
A shutter built into the lens to allow flash synchronization at all shutter speeds.

Bit
A binary digit, either 1 or 0.

Blooming
Halos or streaks visible around bright reflections or light sources in digital pictures.

BMP
File format for bitmapped files used in Windows.

Boom
An attachment for a studio light that allows the light to be suspended at a variable distance from the studio stand.

Bracketing
Method of exposing one or more frames either side of the predicted exposure and at slightly different exposures.

Buffer RAM
Fast memory chip on a digital camera.

Byte
Computer file size measurement.
1024 bits=1 byte
1024 bytes=1 kilobyte
1024 kilobytes=1 megabyte
1024 megabytes=1 gigabyte

C41
Process primarily for developing colour negative film.

Cable Release
An attachment that allows for the smooth operation of the camera's shutter.

Calibration
Means of adjusting screen, scanner, etc, for accurate colour output.

Cassette
A light-tight container that 35mm film comes in.

CC Filter
Colour Correction filter.

CCD
Charged Coupled Device. The light sensor found in most digital cameras.

CDR
Recordable CD.

CD-ROM
Non-writable digital storage compact disk used to provide software.

CDS
Cadmium sulphide cell used in electronic exposure meters.

Centre-weighted
TTL metering system which is biased towards the centre of the frame.

Cloning
Making exact digital copies of all or part of an image.

Clip Test
Method of cutting off a piece of exposed film and having it processed to judge what the development time should be of the remainder.

CMYK
Cyan, magenta, yellow and black colour printing method used in inkjet printers.

Colour Bit Depth
Number of bits used to represent each pixel in an image.

Colour Negative Film
Colour film which produces a negative from which positive prints can be made.

Colour Reversal Film
Colour film which produces positive images called transparencies or slides

Colour Temperature
A scale for measuring the colour temperature of light in degrees Kelvin.

Compact Flash Card
Removable storage media used in digital cameras.

Compression
Various methods used to reduce file size. Often achieved by removing colour data (see JPEG).

Contact Sheet
A positive printed sheet of a whole processed film so that selected negatives can be chosen for enlargements.

Contrast
Range of tones in an image.

CPU
Central Processing Unit. This performs all the instructions and calculations needed for a computer to work.

Cross-processing
Method of processing colour film in different developers, ie colour reversal film in C41 and colour negative in E6.

Cyan
Blue-green light whose complementary colour is red.

Dark Slide
A holder for sheet film used in large format cameras.

Data
Information used in computing.

Daylight Balanced Film
Colour film that is balanced for use in daylight sources at 5400 degrees Kelvin.

Dedicated Flash
Method by which the camera assesses the amount of light required and adjusts flash output accordingly.

Default
The standard setting for a software tool or command which is used by a computer if settings are not changed by the user.

Depth of Field
The distance in front of the point of focus and the distance beyond that is acceptably sharp.

Dialog Box
Window in a computer application where the user can change settings.

Diaphragm
Adjustable blades in the lens determining the aperture size.

Diffuser
Material such as tracing paper placed over the light source to soften the light.

Digital Zoom
Digital camera feature that enlarges central part of the image at the expense of quality.

DIN
Deutsche Industrie Norm. German method of numbering film speed, now superseded by ISO number.

Download
Transfer of information from one piece of computer equipment to another.

DPI
Dots Per Inch. Describes resolution of printed image (see PPI).

DPOF
Digital Print Order Format.

Driver
Software that operates an external device or peripheral device.

DX
Code marking on 35mm film cassettes that tells the camera the film speed, etc.

E6
Process for developing colour reversal film.

Emulsion
Light sensitive side of film.

EV
Exposure Value.

EVF
Electronic View Finder found in top quality digital cameras.

Exposure Meter
Instrument that measures the amount of light falling on the subject.

Extension Bellows
Attachment that enables the lens to focus at a closer distance than normal.

Extension Tubes
Attachments that fit between the camera and the lens that allow close-up photography.

F Numbers
Also known as stops. They refer to the aperture setting of the lens.

Feathered Edge
Soft edge to a mask or selection that allows seamless montage effects.

File Format
Method of storing information in a computer file such as JPEG, TIFF, etc.
Film Speed
See ISO.

Filter
A device fitted over or behind the camera lens to correct or enhance the final photograph. Also photo-editing software function that alters the appearance of an image being worked on.

Filter Factor
The amount of exposure increase required to compensate for a particular filter.

Firewire™
High speed data transfer device up to 800 mbps (mega bits per second), also known as IEEE 1394.

Fisheye Lens
A lens that has an angle of view of 180 degrees.

Fixed Focus
A lens whose focusing cannot be adjusted.

Flag
A piece of material used to stop light spill.

Flare
Effect of light entering the lens and ruining the photograph.

Flash Memory
Fast memory chip that retains all its data, even when the power supply is switched off.

Focal Plane Shutter
Shutter system that uses blinds close to the focal plane.

Fresnal Lens
Condenser lens which aids focusing.

Fringe
Unwanted border of extra pixels around a selection caused by the lack of a hard edge.

Gel
Coloured material that can be placed over lights either for an effect or to colour correct or balance.

GIF
Graphic file format for the exchange of image files.

Gobo
Used in a spotlight to create different patterns of light.

Grain
Exposed and developed silver halides that form grains of black metallic silver.

Greyscale
Image that comprises 256 shades of grey.

Hard Drive
Computer's internal permanent storage system.

High Key
Photographs where most of the tones are taken from the light end of the scale.

Histogram
Diagram in which columns represent frequencies of various ranges of values of a quantity.

HMI
Continuous flicker-free light source balanced to daylight.

Hot Shoe
Device usually mounted on the top of the camera for attaching accessories such as flash.

Incident Light Reading
Method of reading the exposure required by measuring the light falling on the subject.

Internal Storage
Built-in memory found on some digital cameras.

Interpolation
Increasing the number of pixels in an image.

Invercone
Attachment placed over the exposure meter for taking incident light readings.

ISO
International Standards Organization. Rating used for film speed.

Jaggies
Images where individual pixels are visible due to low resolution.

JPEG
A file format for storing digital photographs where the original image is compressed to a fraction of its original size.

Kelvin
Unit of measurement of colour temperature.

Latitude
Usable film tolerance that is greater with negative film than reversal film.

LCD
Liquid Crystal Display screen.

Light Box
A light with a diffused screen used for viewing colour transparencies.

Lossless
File compression, such as LZW used in TIFF files, that involves no loss of data or quality in an image.

Lossy
File compression, such as JPEG, that involves some loss of data and thus some quality in an image.

Low Key
Photographs where most of the tones are taken from the dark end of the scale.

Macro Lens
A lens that enables you to take close-up photographs.

Magenta
Complementary colour to green, formed by a mixture of red and blue light.

Marquee
An outline of dots created by an image-editing program to show an area selected for manipulation or work.

Mask
An 8-bit overlay that isolates part of an image prior to processing; the isolated area is protected from change. The areas outside the mask are called the selection.

Megapixel
1,000,000 pixels.

Mirror Lock
A device available on some SLR cameras which allows you to lock the mirror in the up position before taking your shot in order to minimize vibration.

Moiré
An interference pattern similar to the clouded appearance of watered silk.

Monobloc
Flash unit with the power pack built into the head.

Montage
Image formed from a number of different photographs.

Morphing
Special effect where one image changes into another.

Network
Group of computers linked by cable or wireless system so they can share files. The most common form is ethernet. The web is a huge network.

Neutral Density
A filter that can be placed over the lens or light source to reduce the required exposure.

Noise
In digital photography, an effect that occurs in low light that looks like grain.

Optical Resolution
In scanners, the maximum resolution possible without resorting to interpolation.

Pan Tilt Head
Accessory placed on the top of a tripod that allows smooth camera movements in a variety of directions.

Panning
Method of moving the camera in line with a fast moving subject to create the feeling of speed.

Parallax Correction
Movement necessary to eliminate the difference between what the viewfinder sees and what the camera lens sees.

PC Card
Removable cards that have been superseded by flash cards.

PC Lens
Perspective control or shift lens.

Peripherals
Items connected to a computer, such as scanners.

Photoshop
Industry standard image manipulation package.

Pixel
The element that a digitized image is made up from.

Plug-in
Software that adds extra features to image-editing programs.

Polarizing Filter
A filter that darkens blue skies and cuts out unwanted reflections.

Power-up time
Measure of a digital camera's speed of operation from being switched on to being ready to take a photograph.

Predictive Focus
Method of auto-focus that tracks a chosen subject, keeping it continuously sharp.

Prop
An item included in a photograph that enhances the final composition.

Pulling
Decreasing the development of the film.

Pushing
Rating the film at a higher ISO and then increasing the development time.

Quick mask
Photoshop mode that allows a mask to be viewed as a colour overlay on top of an image.

RAM
Random Access Memory.
Rangefinder Camera
A camera that uses a system which allows sharp focusing of a subject by aligning two images in the camera's viewfinder.

Reciprocity Failure
The condition where, at slow shutter speeds, the given ISO does not relate to the increase in shutter speed.

Refresh Rate
How many times per second the display on an LCD preview monitor is updated.

Resizing
Altering the resolution or physical size of an image without changing the number of pixels.

Resolution
The measure of the amount of pixels in an image.

RGB
Red, Green and Blue, which digital cameras use to represent the colour spectrum.

Ring Flash
A flash unit where the tube fits around the camera lens, giving almost shadowless lighting.

ROM

Read Only Memory.

Saturation

The amount of grey in a colour; the more grey present, the lower the resolution.

Selection

In image-editing, an area of a picture isolated before an effect is applied; selections are areas left uncovered by a mask.

Shift and Tilt Lens

Lens that allows you to shift its axis to control perspective and tilt to control the plane of sharp focus.

Shutter

Means of controlling the amount of time that light is allowed to pass through the lens onto the film.

Shutter Lag

The delay between pressing the shutter release and the picture being taken.

Shutter Priority

Metering system in the camera that allows the photographer to set the shutter speed while the camera sets the aperture automatically.

Slave Unit

Device for synchronizing one flash unit to another.

SLR

Single Lens Reflex camera.

Smart Media

Type of digital camera removable media used by some camera manufacturers.

Snoot

Lighting attachment that enables a beam of light to be concentrated in a small circle.

Spill

Lighting attachment for controlling the spread of light.

Spot Meter

Method of exposure meter reading over a very small area.

Step Wedge

A greyscale that ranges from white to black with various shades of grey inbetween.

Stop

Aperture setting on a lens.

T Setting

Used for long time exposures to save draining the camera's battery.

Tele Converter

Device that fits between the camera and lens that extends the lens' focal length.

Thumbnail

A small, low-resolution version of an image, used like a contact sheet for quick identification.

TIFF

Tagged Inventory File Format. The standard way to store digital images.

TLR

Twin Lens Reflex camera.

TTL

Through The Lens exposure metering system.

Tungsten Balanced Film

Film balanced for tungsten light to give correct colour rendition.

TWAIN

Industry standard for image acquisition devices.

Unsharp masking

Software feature that sharpens areas of high contrast in a digital image while having little effect on areas of solid colour.

USB

Universal Serial Bus. Industry standard connector for attaching peripherals with date transfer rates up to 450 mbps (mega bits per second).

Vignetting

A darkening of the corners of the frame if a device such as a lens hood or filter is used that is too small for the angle of view of the lens.

White Balance

Method used in digital cameras for accurately recording the correct colours in different light sources.

ZIP

An external storage device which accepts cartridges between 100 and 750 megabytes.

Zoom Lens

Lens whose focal length is variable.

Index

Acknowledgements

John Freeman and Anova Books would like to thank Calumet Photographic UK and Fuji UK for their assistance in the production of this book.

This book would not have been possible without the help of many people. In particular I would like to thank Alex Dow for his dedication to the project and his technical expertise, especially in the area of digital photography. There are few people who have his knowledge. I would also like to thank Chris Stone, my commissioning editor, for making it happen on time; Teresa Neenan for faultless travel arrangements through Trailfinders; Nigel Atherton and Jamie Harrison at *What Digital Camera* magazine; Gomed Jangframol; Chumsak Kanoknan; Mr Kim; Michy; Dr Nilpem Pramoth; Varan Suwanno and Vanessa Freeman for being there.